Vincent van Gogh

BY INGRID SCHAFFNER

THE WONDERLAND
PRESS

Harry N. Abrams, Inc., Publishers

THE WONDERLAND PRESS

The Essential™ is a trademark
of The Wonderland Press, New York
The Essential™ series has been created by The Wonderland Press

Design by DesignSpeak, NYC

Library of Congress Catalog Card Number: 98-71931
ISBN 0-8109-5813-9

On the end pages: Wheatfield with Crows. 1890. Van Gogh Museum
Amsterdam, The Netherlands. Photo Art Resource, NY

Unless caption notes otherwise, works are oil on canvas

Printed in Hong Kong

Harry N. Abrams, Inc.
100 Fifth Avenue
New York, NY 10011
www.abramsbooks.com

Contents

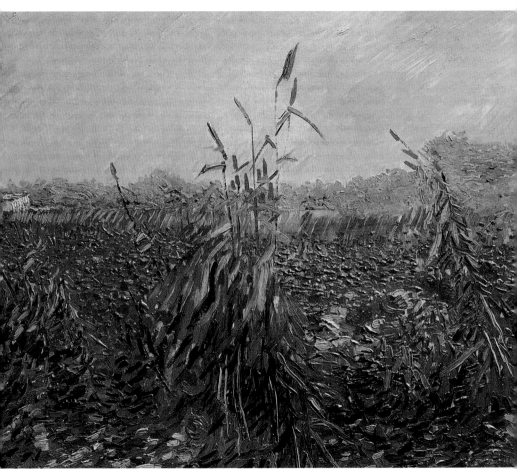

The Essential Van Gogh

Vincent van Gogh (1853–1890) is a legendary figure both in art history and in popular culture. One might even say that his legend is so vast that it verges on *mania*. In looking at his paintings and drawings today, **you may find it hard to separate the art from the myth**—or to see his pictures as more than mere illustrations that accompany a sensationally depressing biography. This book gives you a handle on all of the above—the art, the life, the legend—and will help you look at a body of art that is every bit as powerful as the legend, or *mania,* surrounding it.

OPPOSITE
Field with Poppies. 1888
21 ¼ x 25 ½"
(34 x 65 cm)

Van Gogh *Mania*

Van Gogh is everywhere: "Sunflower" cocktail napkins and t-shirts (cultured souvenirs)…the Don McLean song, *Vincent* ("Starry Starry Night")…*Lust for Life,* the biography by Irving Stone and film starring brawny Kirk Douglas as the crazy artist…posters of *Irises* wall-papering college dormitories around the world…. You get the point.

These are symptoms of what might be called Vincent van Gogh *mania,* a strange fascination that has smothered with kitsch one of the most profound artists of the modern period. Granted, Van Gogh's story is first-rate tabloid copy for that ever-popular fairy tale of the *Misunderstood Artistic Genius.* After all, he was:

- **A MARTYR,** who cared passionately about art and who devoted his tormented life to it

- **A FAILURE,** who sold only one work during his lifetime and committed suicide

- **A MADMAN,** who spent much of the last part of his short life in an asylum for the insane

- **A HERO,** glorified by the high prices his art now fetches

What do these myths have to do with his art? Without his paintings and drawings—which are actually the result of hard work and focused intelligence, not of lunacy—why would we care about the legend? This book will explain why. It's a back-to-basics look at Vincent van Gogh that makes the essentials of his art—key pictures, critical interpretations, historical, and, yes, biographical background—as easy to understand as the answer to this quiz question: *"Which late-19th-century Dutch Post-Impressionist painter cut off his own ear?"*

BACKTRACK:
IMPRESSIONISM

Peak period:
1870s

Key players:
Edouard Manet (1832–1883),
Claude Monet (1840–1926),
Pierre-Auguste Renoir
(1841–1919)

Subjects:
The pleasures of bourgeois
life: luncheons, boating
parties, dress-ups, theater,
ballet, brothels, gardens,
horse races, family life

Characteristics of painting:
Attempt to "scientifically"
represent transient effects
of light and movement,
objectively and without
interpretation. Dappled
brushwork dissolves into
atmospheric compositions
of clear, vibrant colors

> **FYI:** How to say "Van Gogh?" Americans say "go";
> the Dutch say "gock" or "hock." (You say Po-tay-to;
> I say Po-tah-to...) His name can be found under "G"
> (not "V") in most references.

Why do People Line Up to see Van Gogh?

Nothing in Van Gogh mania even approaches the impact of looking at his art. Van Gogh communicated a vision of the world as he experienced it, making no attempt to create a realistic image of his subjects. However subjective the pink skies, twisted figures, or sinewy black outlines might appear, all are based on his experience and careful observation of them.

No isolated nut, the painter was informed and completely engaged in the issues of his day. He worked hard, with great seriousness and commitment. Through the lens of his own imagination, he painted the world around him in its fullest sense: nature, culture, imagination, emotion, physicality, and abstraction all synthesized into cohesive pictures, concisely expressed. Van Gogh's works are about *art as experience;* Van Gogh himself experienced *everything* through art.

To really *get* Van Gogh, you have to stand in front of his art and observe:

- the emotional **power of space**

- the symbolic meaning of **color**

- the **physicality** of the medium

- the sheer **beauty** and intelligence of his images

Try getting *that* from a reproduction on a cocktail napkin!

FYI: Who put the "post" in Post-Impressionism? Neither term (Impressionist nor Post-Impressionist) was in common use during the painters' lives. (Claude Monet didn't introduce himself at parties, "Bonjour, je suis un Impressioniste.") In their day, the Impressionists worked under the rubrics of "The New Painters" or "The Painters of Modern Life." They were dubbed "Impressionists" by a scornful art critic who, reviewing their 1874 exhibition, found it to be a bit of a blur—an *impression* of reality rather than reality itself. The term Post-Impressionism is historical jargon coined many years after the fact by English art historians Roger Fry and Clive Bell—and probably as a matter of convenience ("What do we *call* them?").

OVERLEAF

TOP LEFT
A Pair of Shoes
1886. 15 x 18 ⅛"
(37.5 x 45.5 cm)

TOP RIGHT
Landscape at Montmajour with Train
(no date)

BOTTOM
Breton Peasants
1888. Watercolor
18 ⅞ x 24 ⅜"
(47.5 x 62 cm)

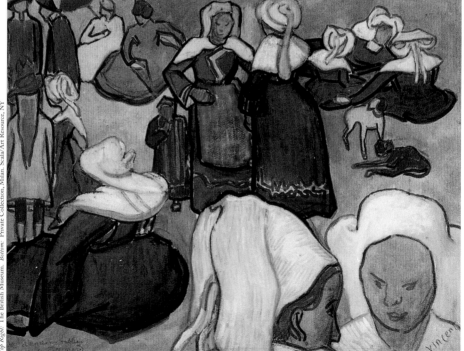

An Artist of the Post-Impressionist Period

As the name says, Post-Impressionism was a period ("after Impressionism") rather than a formal movement. Unlike the artists who originated Impressionism, who were all based in Paris, who shared a common subject matter and exhibited together regularly from 1874–86, the Post-Impressionists were a makeshift and far-flung group. True, they each passed through an Impressionist period, but their work, developed in isolation from one another, remains distinct. (Put a Cézanne next to a Van Gogh and you'll see this.) Post-Impressionism is a term used retrospectively by critics, but never by the artists themselves.

What did the Post-Impressionists get from Impressionism?

The short answer: A whiff of how radically different a painting can be from reality. Because however objectively the Impressionists claimed to paint, their systematic devotion to brushwork and color was also patently artificial. They painted brushstrokes to look like brushstrokes, impressions to feel like sensations. Still, it's a representation and not the real thing.

**BACKTRACK:
POST-IMPRESSIONISM**

Peak period:
1880s

Key players:
Van Gogh; Paul Cézanne
(1839–1906), based in
Aix-en-Provence, France;
Paul Gauguin (1848–1903),
based in Brittany (France)
and then Tahiti

Subjects:
Nature and an idealized
life within it

Characteristics of painting:
Attempt to express subjective
reality by extracting from
the traditional stuff of
representational painting—
perspective, color, line—
abstract or symbolic expressions

What were the Post-Impressionists into?

- they changed the role of the artist from slave-of-nature to constructor-of-reality

- they changed the perception of paintings from metaphorical "mirrors" and "windows" to objects in their own right

- they launched modern art: Symbolism, Cubism, Expressionism, Surrealism, and Abstract Expressionism (to name only a few "isms") are all legacies of Post-Impressionism. (Stay tuned to learn how Van Gogh, as a Post-Impressionist artist, would become known as a pre-Expressionist painter.)

Upheaval of Van Gogh's Times

Many of the conflicts Van Gogh expressed in his art are reflections of the times at large. By the late 19th century, the Industrial Revolution had transformed the world as people had known it. Here are some of the conditions of life in Van Gogh's times that rebound in his paintings:

- the economy changes from an agrarian to an industrial one

- people in search of factory work are hightailing it from the farms to the cities and newly created suburbs

- the newly mobile people travel rapidly and in mass numbers on trains—the fast, noisy, new-fangled scourges of the countryside

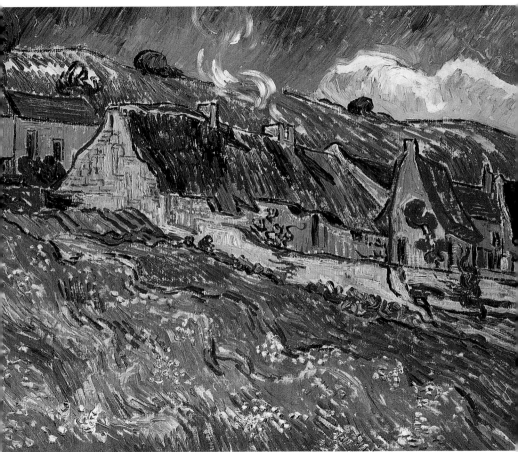

- they leave behind their churches, families, and other close-knit forms of community established over generations in search of:

 (a) **unlikely answer:** middle-class lures of dazzling department stores and leisure time
 (b) **probable answer:** a working-class reality of dank, over-crowded slums and abysmal working conditions

- once in the cities, they long for contact with nature

- people experience extreme loneliness, alienation, and anonymity within the crowded public life of streets, cafés, bars, restaurants, etc.

- they gain a new visual perspective: From atop the Eiffel Tower, from the basket of a hot-air balloon, from an apartment building, even from a seat on the train, the modern world looks different

NOW To have a fairly good handle on the fundamental neuroses of modern life, imagine the normal anxieties, anticipation, and ambivalence each of us has when leaving home for the first time, with everybody—even the old-timers who stay put—feeling the impact. Van Gogh's art is powerfully (and sensitively) in tune with the conflicted, modern-day consciousness, even today. Anyone who has ridden a packed subway or been stuck in a traffic jam on the way to work and started dreaming of the High Sierras can still call those conflicts their own.

OPPOSITE
Sunflowers
1887. 17 x 24"
(43.2 x 61 cm)

This is one reason why Van Gogh's art continues to attract fresh batches of ardent viewers to museums around the world: To ad-lib our talk-show hosts and television evangelists, *in the late, great state of 20th-century capitalist culture, Vincent shows us our pain.*

So.... Who was He?

Vincent Willem van Gogh was the son of the **Rev. Theodorus van Gogh,** an evangelical Calvinist, and **Anna Cornelia Carbentus.** Born on March 30, 1853 (an Aries) in Groot-Zundert, in North Brabant, Holland (the Netherlands), near the Belgian border, he was not the first Vincent van Gogh (nor was he the last: his brother Theo would also name his son Vincent). There was:

- **GRANDFATHER VINCENT:** a highly respected Protestant minister and brilliant scholar

- **UNCLE VINCENT:** an art dealer with the venerable European firm, Goupil and Company

- **BABY VINCENT:** his still-born brother, who was born exactly one year earlier. (Attention psychologists: red light, danger, warning.)

The Replacement Child Syndrome

Virtually everything in Van Gogh's life and art can be seen in terms of conflict. He spends the first twenty-seven years of his life trying to discover his true calling, first as an art dealer (shades of Uncle Vincent), then as a pastor (hello Grandpa). He spends his childhood going to church, where his brother lies buried under a stone that is carved with *their* name: Vincent. (Yikes!) Like a lost twin, he spends his entire life feeling as though he is: (1) a replacement child for the first (dead) Vincent, and (2) divided from part of himself. Later, as an artist, he signs his paintings simply "Vincent," feeling that he never wholly belonged as a "Van Gogh." (Parallel universe: The lifelong absense of Elvis Presley's dead twin always made Elvis feel as if he was only half a Presley.)

The Young Vincent as Art Dealer: 1869–1876

At the age of 16, under the auspices of his Uncle Vincent (Uncle "Cent"), a former partner in the firm,

BACKTRACK: THE BARBIZON SCHOOL

French landscape painters, including Charles-François Daubigny (1817–1878) and Jean-François Millet (1814–1875), who took their name from the little town of Barbizon, near Paris, where they settled starting in the late 1840s. Their landscapes, which they painted with near-religious reverence and in ever-softening light, depict peasant life and the quality of natural light on objects. Though they advocated drawing directly from nature, they were actually studio painters who completed their works indoors, based on voluminous sketches.

Van Gogh becomes an employee of the Paris-based Goupil and Co. at its branch in The Hague—located in a gallery once owned by Uncle Cent. Goupil and Co. represents both historic and contemporary artists; they also publish reproductions of art. As a promising junior partner, Van Gogh is promoted to their London office in May 1873, where he reads, visits museums, and observes nature; he then does a stint in Paris from October to December 1874, when he returns to London. In May 1875 he is permanently transferred back to Paris. Seven months later, he is fired. It is during this period that Van Gogh:

- learns first-hand about art and begins to develop his own tastes

- discovers his affinity for artists of the French Barbizon School and their Dutch counterparts of the Hague School (such as Anton Mauve)

- grows infatuated with his British landlady's daughter, Ursula Loyer, who spurns him in the summer of 1883, establishing the basis of what will become an unhappy pattern in his relations with women: obsession met with rejection followed by depression

- starts corresponding with his younger brother, Theo van Gogh (1857–1891), who also enters the Goupil firm in 1873 in their Brussels office. (Vincent writes to Theo: "I am so glad that we shall both be in the same profession and in the same firm. We must be sure to write to each other regularly.") Unlike Vincent, Theo stays and makes a lifetime career of art dealing.

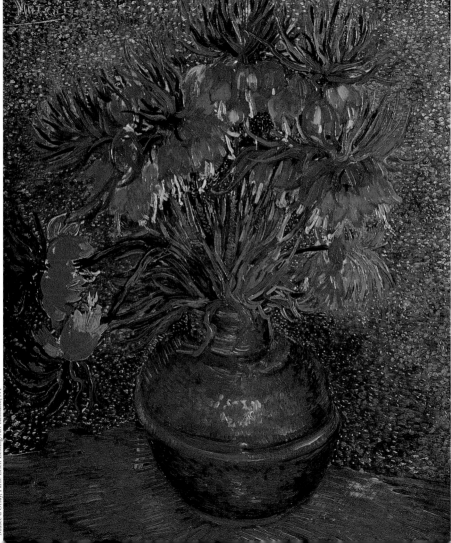

absolument comme d'ajuster qu...
n échange quelque chose que l...
...qu... luimeme & surtout av...
les luis lorsqu'il les a... lu
Il faut encore savoir que si tu les...
...ci... **soit la berceuse au milieu**

alors tu comprendras ce que je t'en ée...
n... dée avait été de faire une décora...
...tel par exemple pour le fond d'un...
...navire. Alors le j... m... s'élarg...
...end sa raison d'être... de cadre du m...
...ouge. Et les deux tournesols que...
...tourés de baguettes.

Letters to Theo (and Others)

More than 600 letters remain, beginning in August 1872, with letters to brother **Theo, his lifelong correspondent.** Other pen pals are his sister Wil and the artists Emile Bernard and Paul Gauguin. (Van Gogh corresponded in English, French, and Dutch.) The first extensive publication of the letters was in 1914 with a three-volume edition arranged by the artist's sister-in-law, Johanna Bonger. In 1952–54, the first attempt at a complete edition appeared, edited by Vincent's nephew and namesake, Vincent Willem van Gogh. These were published in English translation in a three-volume set in 1958. For research purposes, each letter has been assigned a number. A scholarly battleground exists over the exact chronology.

ABOVE
Theo van Gogh

BELOW LEFT
AND OPPOSITE
Letters to Theo

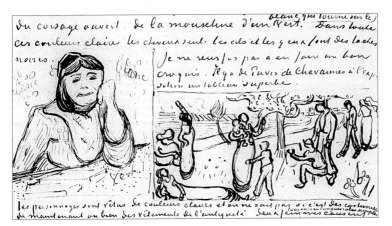

Why are the letters Significant?

Van Gogh clearly articulated his inner life, his visions, desires, and despairs. He detailed what he saw, what he read, who he met, what he did, drew and painted, how much he spent on paint, what he intended his art to communicate and how. Many letters are illustrated with sketches of works in progress—an attempt, some say, to show his benevolent brother that he was indeed being productive. The letters are one of the most thorough and moving narratives of modern art. While Van Gogh's behavior may have been insane, his thinking, as revealed in his letters, was extraordinarily lucid and focused.

Van Gogh as Zealous Evangelist: 1876–1880

Starting in Paris in 1875, Van Gogh's letters to Theo are routinely filled with admonishments that Theo cast away all novels and read only the Bible, from which he quotes liberally and at length. In his increasing obsession with spiritual matters, Van Gogh vocally disapproves of worldly possessions (hello! art??). This proves to be a bad

move for his career as an art dealer, and he is fired from Goupil in January 1876 at the age of 23.

Determined to do some good in the world, he returns to England in April to teach at a boy's school. His real passion, however, is to preach the Gospel, so he resolves to enter the Church. Thus begins a period of struggles and failures, made especially gloomy by the overshadowing brilliance of his clerical father and grandfather. When he goes home for Christmas, Van Gogh decides to remain in Holland. He spends the first few months of 1877 working in a bookstore and devotes hours each day to copying out pages of the Bible. Then, in May, he moves to Amsterdam, where he lives with relatives and prepares for the entrance exam to the Theology Seminary. It's a disaster. For 15 months, Van Gogh studies hard but is distracted by his passionate desire to go out and work among the poor. Finally, even his tutor encourages him to quit training.

In July 1878, Van Gogh abandons the test and heads to an evangelical school in Brussels. Eager to spread God's word, he soon drops out of school without getting his certification and heads to the south of Belgium to preach and work among the sick. In January 1879,

BACKTRACK: THEO VAN GOGH

Vincent van Gogh's younger brother, henceforth referred to as Theo, was a contemporary art dealer based in Paris. He was Vincent's sustaining connection to the world, a constant correspondent, a source of companionship and support—both financial and emotional. Vincent called Theo his "other half." Having married Johanna Bonger in 1889—their one son being named after his uncle Vincent—Theo died just six months after his brother.

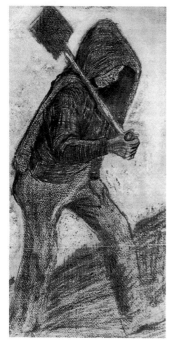

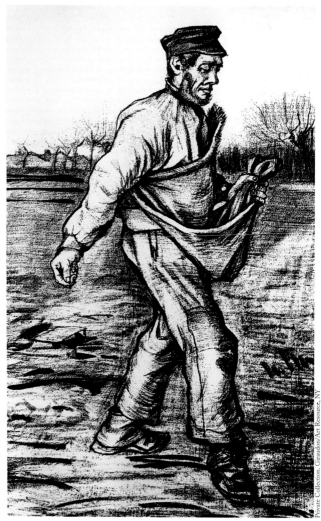

this initiative earns him a short-lived position as a lay preacher in Wasmes, but he is soon fired for his excessive zeal. (He had been hired to teach Bible classes and help the sick, but he went overboard by trying to be Jesus himself. He gave away his money and possessions and moved into a miserable hut. **His zeal alienated the parish** and, in July, they asked him to *please leave.*)

From Failed Evangelist to Gung-Ho Artist: Summer 1880

"Fired" from the church, Van Gogh walks to Brussels to seek advice from a mentor, Reverend Pietersen, who, coincidentally, happens to be a painter in his spare time. The two men visit Pietersen's studio and Van Gogh shows him some sketches he made of the miners while in

BACKTRACK:
JEAN-FRANÇOIS MILLET

French painter of the Barbizon School (1840s) who saw peasants in the same warm and fuzzy light that his colleagues envisioned the landscape. A talented draftsman, Millet (1814–1875) rendered figures as simple sculptural forms at the same time as he transformed sowers, reapers, and farming in general into a blessed vocation performed by noble, beatific beings. In Millet's essential work, *The Angelus* (1859), the peasants are kneeling in prayer after a day of toiling in the soil, while the sun sets resplendently. It is among the most reproduced paintings of the 19th century.

Wasmes. Pietersen encourages him to go back to helping the miners, so Van Gogh returns to the Borinage area of Belgium, this time to Cuesmes. Without any official duties, he spends more time reading and drawing.

FAST FORWARD: He continues to work among the miners, draws them, **discovers that his true vocation is to be an artist,** not an evangelist. In October, he goes to Brussels to take classes in perspective and anatomy (courtesy of Theo, who, by the way, isn't exactly rolling in dough himself).

FYI: **Primitivism**—"*Peasant-Romance*" is an aspect of primitivism, a major phenomenon of modernism. Cultures beyond the direct impact of Western society and technology (what we like to think of as "civilization") were considered to be in their childhoods. It was believed that, eventually, "they" (Asians, all indigenous peoples, peasants…) would grow up to be just like urbanized Europeans. But until then, as children, they were to be indulged, patronized, and ruled. (Of course, the fallacy of primitivism is that its subjects are not in formative or degenerative stages of our culture; each is its own culture.)

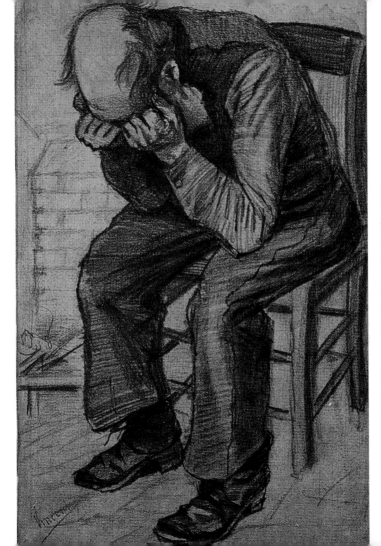

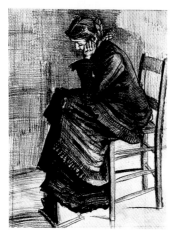

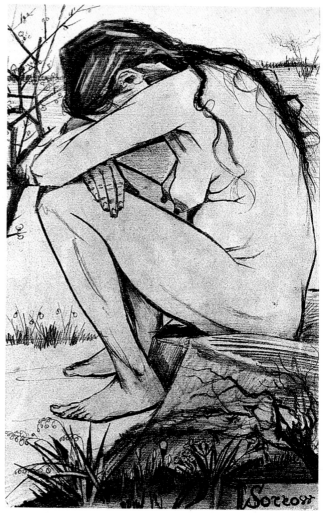

Reality Check:

- it's 1880

- Van Gogh is 27

- he has only just picked up a pencil!

- he is smart, sophisticated, revved with religious and social fervor, desperate to make something of himself. But in his family's eyes (and in his own), he is a **failure.** With the repressed energy of a convert, he turns his zeal onto art. *Art will be his salvation, even though he truly doesn't have a clue how to paint!* Unbeknown to him, he has ten (count 'em—10!!!!) short years left to live. We're talking compressed, explosive…exhausting!

> *FYI:* **Van Gogh's artistic training**—Although Van Gogh took some art lessons here and there, he had basically no formal training in art. He taught himself how to make art by drawing from a hand-picked, diverse, and peculiar group of references in art, literature, and trashy tabloids. As you will see, when it comes to finding sources for his art, *Van Gogh was a consummate sampler.*

**BACKTRACK:
THE HAGUE SCHOOL**

The Hague School (1860–1900) did unto Dutch landscape (dunes, marshes, churches) as the French Barbizon painters had done unto the Forest of Fontainebleau: observed and idealized its charms. As exemplified by a leading exponent (and cousin of Van Gogh), Anton Mauve, they had added a characteristically Northern interest in light and revived many of the traditions of 17th-century landscape painters.

Holland and the Peasant Years: 1881–1885

OPPOSITE

TOP LEFT
The Weaver
1884
Watercolor

TOP RIGHT
Thatched Roofs
1884. Gouache
on paper

BOTTOM
*Weaver Facing
Front.* 1884
Oil on canvas
on panel
18 ⅞ x 24"
(48 x 61 cm)

Van Gogh spends his first years as an artist studying peasant life in his native Holland. His depictions are willfully crude (crude lines for crude lives) as befit **Peasant-Romance,** by which means artists of the time romanticized peasants to be:

- simple, noble salts-of-the-earth

- in tune with eternal rhythms of chaos and order

- close to the earth and therefore to God and nature

The French painter **Jean-François Millet** (1814–1875) was famous for his depictions of humble, holy farmers, their cherubim children, and their close proximity to heaven on earth. *Millet's influence on Van Gogh's art cannot be overstated.*

Van Gogh's art of this period is distinguished by (yes!) a **conflict** over what vision he wants to extract from Dutch peasants:

- Symbolic abstraction or social realism: Were peasants pure souls laboring for God, or dirt farmers struggling for their lives?

Sound Byte:

"I draw, not to annoy people, but to amuse them, or to make them see things that are worth observing and that not everybody knows."

—VINCENT to Theo, 1882

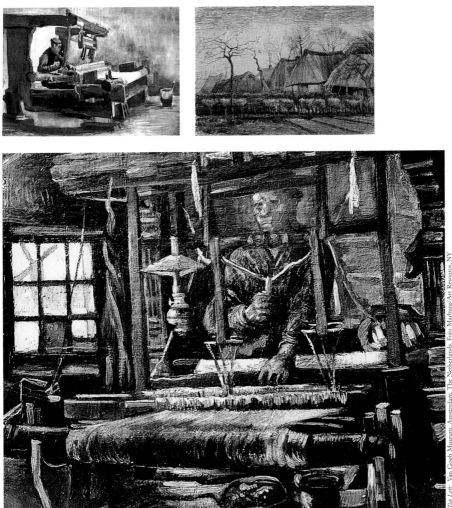

What he especially wants to see, in either case, is **failure.** A recurrent motif of the Holland pictures is a seated figure (peasant, female nude, old man), head in hands, crushed by life, beyond prayer—a melodrama of despair, depicted with compassion. He called these drawings "figures," not portraits, since they usually depict an attitude or gesture rather than a fully fleshed-out subject.

Etten (1881)

After a family council ("What *do* we do about Vincent?"), Van Gogh is sent home to Holland to live with his parents in Etten. **He hones his talents of observation** by drawing the moors and farms, peasants in the fields, and children. He also makes extensive copies after Millet. He visits The Hague for two weeks to apprentice with his distant cousin, the artist **Anton Mauve** (1838–1888), who introduces him to painting. (Van Gogh's first work, very Dutch: cabbages and clogs.) Back in Etten, his parents reproach him for the attachment he has formed to his widowed cousin, Kee Vos-Stricker (known as **Kate**), who sharply rejects his overtures. He, in turn, refuses to attend his father's church service on Christmas Day, telling him that he finds "the whole system of religion abhorrent." His father throws him out of the house.

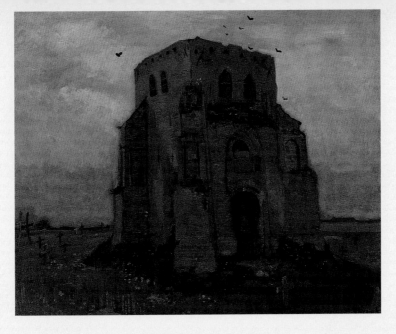

PEASANT CEMETERY (1885)
24 ¾ x 31 ⅛" (63 x 79 cm)

Amsterdam, Van Gogh Museum (Vincent van Gogh Foundation)

Symbolic narrative: You don't need Freud to see conflicts here (remember, Dad was a minister, and the artist—a failed minister—had rejected his father's church):

- little crosses huddling around church ruins
- windows and doors as blind apertures
- the church turning away from the viewer, like a giant's back
- a heavy sky spotted with wheeling crows
- the spring of the earth in bloom from which crosses seem to sprout

Van Gogh's intent: "I wanted to express how very simple dying and being buried are...nothing but some earth dug up—a small wooden cross. And that ruin tells me how a creed and religion have moldered away."

Begins to paint in The Hague: 1881–1883

OPPOSITE
*Peasant Woman
Near the Fireplace*
1885
11 ¾ x 15 ¾"
(29.5 x 40 cm)

With help from Mauve, Van Gogh settles in The Hague in December 1881 and continues his apprenticeship until the two have a falling-out in the spring of 1882. In the meantime, Van Gogh has taken in a young woman named Clasina Maria Hoornik, called **Sien** or, simply, "the woman," a pregnant prostitute with syphilis, whom he determines to marry. (Sien is the model for the forsaken woman of *Sorrow*, 1882.) From his Uncle Cornelius Marinus, he receives a first commission to make *Twelve Views of The Hague.* Instead of depicting the city's picturesque quaintness, Van Gogh sets his sites on the edges of town, the pressure points of industrialization—shabby housing, tangled new tram lines and railroad tracks, bustling workforces. Needless to say, this isn't what Uncle C.M. (as he's called in the letters) bargained for.

Theo is not too thrilled about Sien and pressures Vincent to cool it; but it is Van Gogh's own feelings of artistic inadequacy *(why can't Theo sell my work?)* and Sien's indifference that eventually end the affair. In September 1883, he leaves for Drenthe, Holland, to spend three months roaming the moors and mourning.

> *FYI:* Life with Vincent was no picnic. Theo's friends complained about his scruffy, surly brother. On the other hand, having Vincent around proved good for Theo's business. He cultivated a following among the modern painters, whose work Theo would increasingly represent.

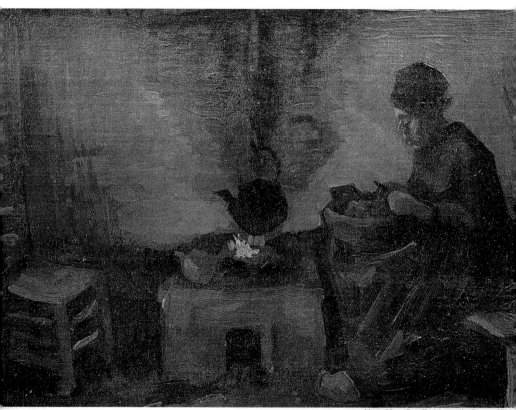

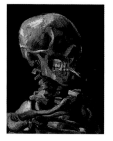

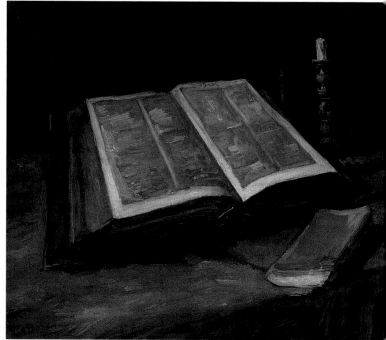

Back Home with Ma & Pa

Having patched things up with his folks (only somewhat, though: in his letters he says he feels like an *unwanted dog*), he moves back in with them at Nuenen in December 1883 and undertakes a series of pictures of weavers (page 31). Against a political backdrop of labor strikes and revolts, Van Gogh creates two images of the industry: (1) **factory weavers,** shown as if trapped inside the mechanisms of their looms, set in empty, pit-of-hell blackness; and (2) **domestic weavers,** seated with dignity before the furniturelike loom at home, near hearth and family.

The Ultimate Rejection

On his own home front, Van Gogh forms an attachment for Margo Begemann, who, for a change, *likes him*, but (hard luck) her parents object; in late 1884 she attempts suicide. This is nothing compared to the seismic shock of March 27, 1885: Van Gogh's father drops dead. Is it a coincidence that shortly after the formidable father's death, Van Gogh produces his first two major works of art, *The Potato Eaters* and *Peasant Cemetery?*

A Pit Stop to Paris: Antwerp

Before leaving Nuenen for Antwerp, Van Gogh paints a still life, *Open Bible, Candlestick, and Novel* (1885), announcing yet another conflict in his art: the alluring temptations of life in the big city. The two main symbols to note in this painting are:

THE POTATO EATERS (1885)
32 ¹/₄ x 44 ⁷/₈" (26.5 x 30.5 cm)

Preparation: Van Gogh's Nuenen sketch-books are filled with feverishly animated studies of peasants; he drew them from life, often in their own cottages, sometimes by lamplight. Made over a period of months, there are copious studies of heads, of hands, and of seated groups—all in preparation for "the scene of those peasants around a dish of potatoes."

Narrative: The meal is the peasants' second breakfast—after chores—and consists of tea and potatoes. The peasants look like potatoes themselves, as if they were dug from the earth or made of dirt. It's still dark outside and the cottage, barely illuminated, is like an animal nest or burrow, full of warmth and community. Note the separateness of the child, whose back faces the viewer, and whose head is haloed in steam and light.

Van Gogh's intent: To make "a genuine peasant painting…(to) portray the peasants in their coarseness…. If a peasant painting smells of bacon, smoke, potato steam, very well, that's not unhealthy. If a field smells of ripe grain and potatoes or of guano and manure, that's quite healthy, *especially for city people.*"

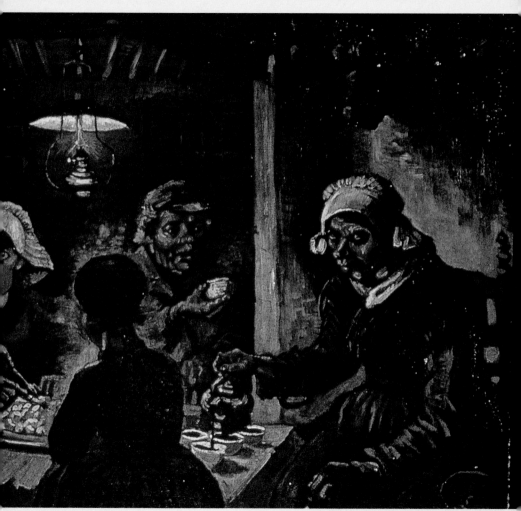

- the Bible, open to *Isaiah*, a book of prophecy that proclaims the sins of the world and eternal damnation

- *La Joie de vivre*, the latest novel by Emile Zola, a scathingly naturalistic observer of modern life whose fiction was the height of urbanity in contemporary Paris

During the brief months he spends in Antwerp (November 1885–February 1886), Van Gogh studies anatomy at the local academy, making unexceptional works except for the screamingly decadent *Skull with a Burning Cigarette between the Teeth* (see page 36). The train for Paris is leaving now!

The Paris Years: Life in the Big City

Up to this point, Van Gogh's work has focused on drawing peasants and on rechanneling his missionary zeal and sense of social responsibility into his art. In Paris (March 1886–February 1888), he focuses on:

- reveling in contemporary painting

- meeting other artists

- making his art more about art

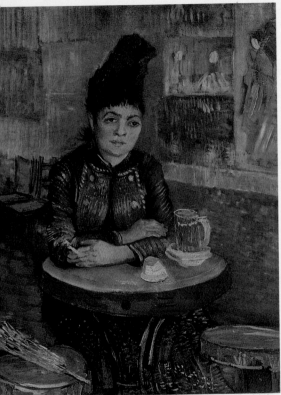

Impressionist Punk

WOMAN AT A TABLE IN THE CAFÉ DU TAMBORIN (1887)

22 x 18 ½" (55.5 x 46.5 cm)

Where: The tambourine-shaped table and chairs reveal the location as 62 Boulevard de Clichy, an artists' café, where Van Gogh presented informal exhibitions of art by himself and his friends, and, on one occasion, an exhibition of Japanese prints.

What: This is a quintessentially Impressionistic image: an individual seated in a café, alone with an abstract look on her face. The subtext goes something like this: in modern times, city people take their private lives into public spaces; they have leisure time and they're bored. (Back on the farm, people were too tired from their chores to have time to be bored.)

How: The painting is Impressionistic in its relatively natural subject, rendered in short brushstrokes. But not entirely: Note the black outlines (hints of Cloisonnism), the stippled dots (Pointillism), and the way the perspective of the wall rushes off into an impossible distance (a hint of Expressionism).

Cool things to note: the woman's bizarre get-up—that hat! She is truly a punk Parisienne. And the print on the wall: It's Japonisme.

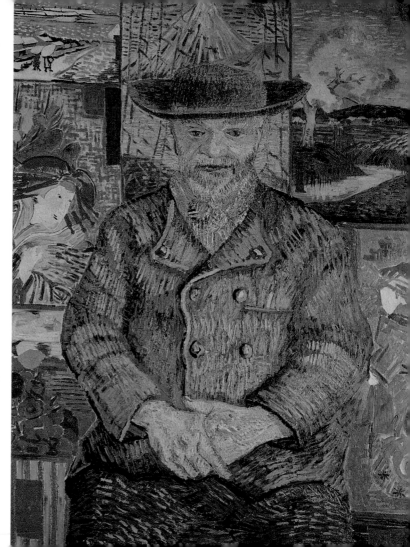

Portrait of Père Tanguy. 1887
36 ¼ x 29 ½"
(65 x 51 cm)

Musée Rodin, Paris. Erich
Lessing/Art Resource, NY

*Julien "Père"
Tanguy was a
pigment grinder
whose shop was
located on Rue
Clauzel near Rue
Lépic. Not only
did he sell artists'
materials—paint,
canvas, brushes—
but he also sold
and collected works
by the artists whose
work he admired.
(For ten years he
was Paul Cézanne's
sole dealer.) As Van
Gogh shows, he was
an avid collector of
Japanese prints.
The portrait shows
a man made by,
and devoted to, art.*

Dabbling and Sampling

He moves in with Theo in Montmartre and attends classes at the studio of Fernand Cormon (studies of plaster casts—conventional enough, save some pretty lively paintings of taxidermed birds and a bat). The important contacts happen outside of class. Contemporary Paris is a pu-pu platter of artistic possibilities in which Van Gogh meets lots of artists and finds (for the first time) a peer group within a community of painters. Stimulated by what he sees and who he meets, the Paris years are highly experimental: You can actually see Van Gogh sampling and spitting out new ideas from one painting to the next as **he rushes at freight-train speed toward the formulation of his own language of art.**

> *FYI:* **Haussmannization**—The making of modern Paris, named for its master planner, Baron Georges-Eugène Haussmann (1809–1891). During the 1850s, the old city, comprised of many small quarters, was razed to make way for one big, uniform plan. Little streets were replaced by grand boulevards; the lower classes were pushed to the outskirts to make way for the middle classes; the center of the city was turned into a fashionable district for shopping, tourism, and new apartment buildings. Haussmann was commissioned by Emperor Napoléon III after a violent uprising in 1848 by socialists, who easily barricaded themselves within the twisted streets of the old city. Haussmannization was the emperor's military strategy to insure against future disobedience: Those big boulevards are specifically designed for the movement of troops and munitions.

Intermission: Van Gogh's Paris Menu

MAIN ENTRÉE:

- *Impressionism:* Though the movement had already peaked by 1886, the Impressionists are the established avant-garde with whom Van Gogh must come to terms. Even though he admired their "nimble blending of colors, the delineation at lightning speed," he was disappointed in Impressionism and moved in another direction: "It all seems slapdash, ugly, badly painted, badly drawn."

SELECTED SIDE DISHES:

- *Pointillism:* A technique formulated by the neo-Impressionist, **Georges Seurat** (1859–1891), whose monumental *Sunday Afternoon on the Island of La Grande Jatte* was first exhibited in 1886. Pointillism was named for the little stippled dots of color that cover the canvas; its main objective was to blend optical impressions and memories to capture the afterimages of modern life. Also called Divisionism.

- *Japonisme:* A taste for things Japanese roared through Western Europe like a tsunami in the wake of Commodore Perry's 1850s trip to the previously closed ports of Japan. During the 1880s, new treaties with France started the wave all over again. The Japanese artist **Ando Hiroshige** (1797–1858) created woodblock prints such as *One Hundred Views of Edo* that strongly influenced Van Gogh in their deliberate violation of the rules of Western perspective. The chief

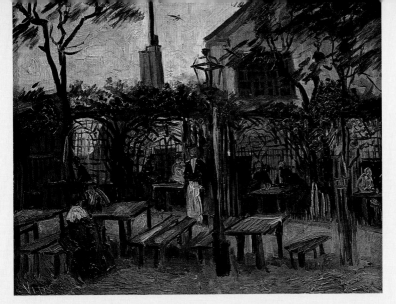

*La Guinguette
à Montmartre*
1886
19 ¹/₄ x 25 ¹/₅"
(49 x 64 cm)

Musée d'Orsay, Paris. Erich
Lessing/Art Resource, NY

characteristics of Japonisme are: (1) colors and patterns laid on in flat, unmodulated planes; (2) radically cropped compositions (figures cut off by the frame are Japonismes); (3) Japanese props and backdrops (everyone was collecting Japanese prints, parasols, textiles, etc.).

- *Cloisonnism:* Formulated by **Paul Gauguin** (1848–1903); named for an enameling technique; characterized by fields of jewel-like color contained in heavy black outlines, like stained glass; its main objective was to distill painting to line and color and to clear the way for subjective and decorative forms of representation. The Cloisonnists' impact was critical to the formulation of modernism.

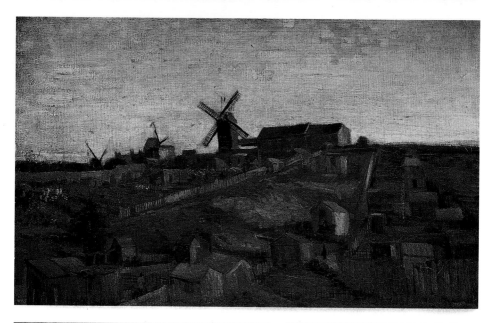

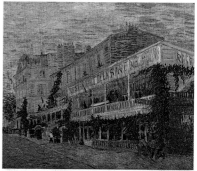

A Dutchman in Paris

In the midst of bohemian Paris, Van Gogh fancies himself to be the lonely Dutchman:

- he tramps around the fringes of the city

- he hangs out in divey bars

- he makes dozens of searching self-portraits

He's soaking up new possibilities in art, but very much on his own terms, starting with the landscape. His turf includes:

- **LA BUTTE MONTMARTRE:** *(the hilly section in the northern part of Paris, known as an artists' quarter):* Drop a Dutchman in Paris and what does he paint? Windmills. The *moulins* were already defunct tourist attractions dotting the hills of Montmartre, but Van Gogh chooses to see them as defiant holdouts of peasant life. *The brushwork is broad (Impressionistic), but the colors are dark and muddy.*

- **THE BANLIEUE:** ("suburbs"): In the wake of Haussmannization, Paris was surrounded by melancholy wastelands, where building stopped and nothing had really begun yet. (Well, maybe a lamp-post.) The suburbs were a cultural subject, the organizing principle for a mock society of artists, who called themselves "La Société de Banlieue." In Van Gogh's depictions of the banlieue, *perspective is*

OPPOSITE

TOP
La Butte Montmartre
1886
14 ¹/₅ x 24"
(36 x 61 cm)

BOTTOM LEFT
Suburb of Paris near Montmartre
1887
Watercolor heightened with white
15 ¹/₂ x 21"
(39.5 x 53.5 cm)

BOTTOM RIGHT
Restaurant de la Sirène at Asnières
22 ¹/₂ x 26 ³/₄"
(57 x 68 cm)

OPPOSITE
*Self-Portrait
with Grey Felt
Hat,* 1887/88
17 ¼ x 14 ¾"
(44 x 37.5 cm)

*stretched beyond the points of reality to achieve maxi-
mum anxiety.*

- **ASNIÈRES:** As the Impressionists had the town of
 Argenteuil, the Post-Impressionists had Asnières,
 a suburb *cum* amusement park on the Seine,
 with boating, picnicking, cafés, and gardens.
 Van Gogh went there with his friend Emile
 Bernard on painting expeditions. Asnières was
 developed and commercialized, but he depicted it
 as a fresh Impressionist landscape: *sparkling colors
 and stroking brushwork.*

Man of a Thousand Faces

Well, 47 to be exact. Of the total number of self-portraits,
24 were painted in Paris. Like the rest of the works of
this experimental period, they reflect a wide range of inspi-
rations, from Impressionism to Mesmerism. They also
render **conflicts of identity.**

Here are two things to observe:

- **DIFFERENT HATS:** Hats demonstrate various personae
 and an attempt to find (or, more accurately, construct)
 personal identity. There's a stylish grey fedora for the

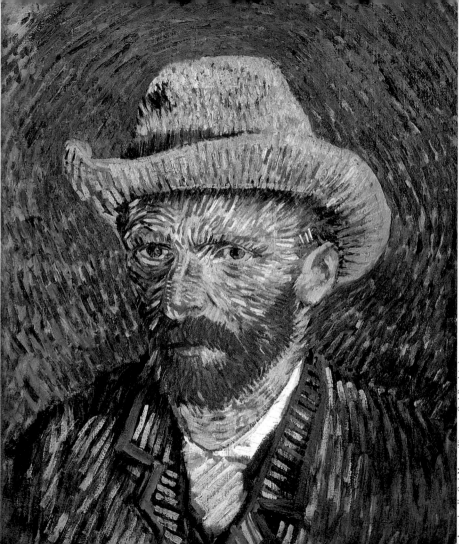

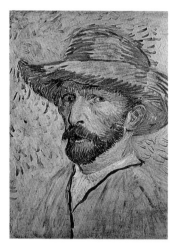

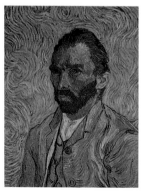

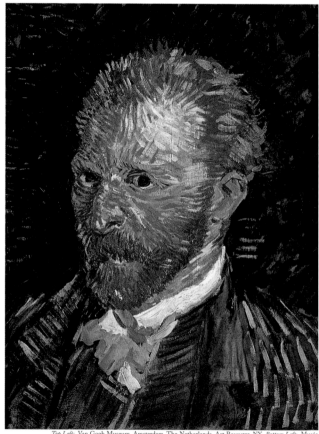

Top Left: Van Gogh Museum, Amsterdam, The Netherlands. Art Resource, NY *Bottom Left:* Musée d'Orsay, Paris. Erich Lessing/Art Resource, NY *Above:* Musée d'Orsay, Paris. Scala/Art Resource, NY

city slicker; a rustic straw hat (which the brushwork can make appear thatched right onto his scalp) for *the country bumpkin;* and when he's humbly hatless, he's the *pious aesthete.*

- **ART DIARY:** The self-portraits show Van Gogh seeing himself through his art, looking naturalistic through the rendered, overlapping strokes of Impressionism, schematized through the stippled dots and lines of Pointillism, and hypnotic (!) with rays of paint turning him and his background into a picture of Mesmerism.

Flower Power

In Paris, Van Gogh paints flowers galore, but the sunflowers are in a category of their own. They encapsulate the innovations of his art to date, as characterized by:

- **AN ACUTE SENSE OF OBSERVATION:** These still lifes are practically portraits. Each flower is like a head with an individual physiognomy of bumps and features. In lieu of hair, there are blazing halos of petals.

- **THE COLORS:** Yellow takes on conflicted associations in Van Gogh's art—at once the color of fields, of modern Paris, and of country life. But when paired with blue—the complement of yellow—the two ennervate one another to a shrill pitch.

OPPOSITE

TOP LEFT
Self-Portrait with Straw Hat. 1887
16 ⅛ x 13"
(41 x 33 cm)

BOTTOM LEFT
Self-Portrait
1889
25 ⅝ x 21 ¼"
(65 x 54 cm)

RIGHT
Self-Portrait
1887
18 ½ x 13 ¾"
(47 x 35 cm)

- **THE BRUSHWORK:** It's as compulsive as Pointillism, but dot, dot, dot has turned into hatch, hatch, hatch—little lines and slabs of paint intricately woven into highly artificial structures that pulse with energy.

- **THE MEANING:** No hothouse blooms, these sunflowers are flowers for the people. They connote the countryside, strong sunlight, and the South—all of which Van Gogh apparently longed to make contact with when he chose to paint sunflowers in Paris during the late summer of 1887.

Leaving for Arles: "I'm outta here..."

After painting the sunflowers (and some grimacing skulls), is it any surprise that within several months Van Gogh quits Paris and heads for the South of France? What he hopes to find there, however, might come as a surprise....

As absurd as it sounds, Van Gogh goes to the South of France to find Japan. Japanese artists, he believes, see things in (literally) a different light. He imagines the sun in Japan to be stronger and artists' perceptions to be clearer—*better*.

Van Gogh's final Paris self-portrait (page 78) announces his new sense of professional identity. He paints himself, hatless, sitting in front of an easel and holding a palette loaded with colors and several paint brushes. He is:

- a working artist

- a "graduate" of Paris

- ready to go out into the world and make his mark

It's not just Japan that he's hoping to find in Arles, but also career opportunities. His goal is to establish an artists' school of the South by attracting fellow "colorists" to join him there. Their community will, in turn, attract the support of writers and critics, whose interest will draw notice from dealers, who will exhibit the *colorists'* work and (yes!) sell their art. In short, Van Gogh leaves Paris with an ambitious plan, optimistic that success—financial, critical, artistic, personal—is imminent. In search of brighter sunshine, Van Gogh goes to Arles to improve his art in a Japanese light. *When he gets there, it is snowing.*

> **FYI: Arles**—Located in Provence, in the South of France, Arles was a Roman town, founded by Julius Caesar. It was more popular with writers than with painters: Stendhal, Alexandre Dumas, Gustave Flaubert, George Sand, Victor Hugo, and the Goncourt brothers all visited Arles. (Perhaps this is what attracted the bookish Van Gogh.) The town is small; a railroad factory is the local industry; bullfighting is a local sport. A Dutch touch is the extensive system of canals, with bridges and embankments, offering excellent vantage points of the landscape.

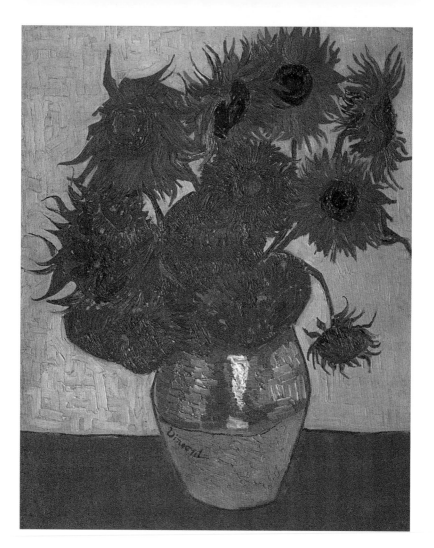

Artistically (at least) he was Right

Loaded with all that he has assimilated and developed while in Paris, Van Gogh is ripe for exploding into maturity. In the fifteen months—or 444 days—that he will live in Arles (February 1888–May 1889), he makes 200 paintings and over 100 drawings. The hallmarks of his mature art are:

- **EXAGGERATED PERSPECTIVES:** space rushes away; landscape is topographical

- **ENERGIZED COLORS:** often paired in complements for optimum dazzle: blue with yellow, pink with lime, red with green

- **HIGHLY GRAPHIC TECHNIQUE:** dots, lines, thatched and woven brushstrokes create a structural language of painting

- **CONSTRUCTED COMPOSITIONS:** self-consciously framed and cropped images

- **EXPLICIT SYMBOLISM:** communicating the intangible

OPPOSITE
Sunflowers. 1888
35 ⁷/₈ x 28"
(91 x 71 cm)

Neue Pinakothek, Munich, Germany. Scala/Art Resource, NY

Sound Byte:
"This country seems to me as beautiful as Japan, as far as the limpidity of the atmosphere and the gay color effects are concerned."
—VINCENT to Theo, 1888

Arriving in Arles

Souvenir de Mauve. 1888
28 ¾ x 23 ⅝"
(73 x 59.5 cm)

Van Gogh arrives in Arles on Monday, February 20, 1888. Physically, he's a wreck. Too much smoking and drinking, and sick from the winter cold. In his search for restoration through warmth and sunshine, he's crushed to find Arles in the midst of an unusual and heavy snowstorm. He rents a room above a restaurant and records his disappointment with a first landscape that makes Southern France look as bleak as the banlieue of Paris. (The painting itself is lackluster Impressionism.) Eventually the weather warms up and so does the artist. The orchards bloom and he sees the Japan that he had hoped to find in the Arles of his mind.

Orchards in Bloom

Between March and April 1888, Van Gogh makes fourteen paintings of fruit trees in bloom. He even describes his project in horticultural terms: "I have nine orchards to work…"; "I now have ten orchards…." He establishes a connection through these trees to the earth and to

FYI: While Van Gogh was working in the orchards, he learned of the death of his teacher, Anton Mauve, and dedicated a painting to him, *Souvenir de Mauve*, as a tribute to the man who had helped him cultivate his own explosive potential.

Sound Byte:

"At the moment, I am absorbed in the blooming fruit trees.... My brush-stroke has no system at all. I hit the canvas with irregular touches of the brush, which I leave as they are. Patches of thickly laid-on color... repetitions, savageries."

—VAN GOGH, describing his orchard paintings to
Emile Bernard, 9 April 1888

meaningful artistic production, such as he missed in Paris. These works are characterized by their:

- **JAPONISME**—he makes a copy of plum blossoms after Hiroshige

- **SENSE OF CONTAINMENT**—he is very focused, he doesn't wander around looking for better trees or pinker blossoms. Most of these paintings are done in the same orchard, which he visits every day as if it were his studio, and these are his still-life subjects

- **ERRATIC BRUSHWORK**—there are moments of Pointillism (coincidentally, the day he left Paris, Van Gogh visited Seurat) mixed with flagrant impasto (application of thick paint), which reveal Van Gogh's obsessive admiration for the work of the Marseilles artist, Adolfe Monticelli (1824–1886). Van Gogh's appreciation of Monticelli's work drives his early development in Arles and prepares him for his own impasto style of painting.

- **CONFLICT**—an orchard is man-made; trees are cut back to bloom and to produce with unnatural intensity. In Van Gogh's painting of spring blooms on wizened branches, nature appears almost in competition with culture.

Japanese Suites

Drawing plays an important role for Van Gogh in Arles. He tells Theo he intends to make lots of works on paper and organize them into suites, which he compares to Japanese prints. His use of a reed pen is

> *FYI:* **Drawing and painting together** (or, what to look for in a Van Gogh drawing)—In Arles, it's as if Van Gogh's drawings are talking to his paintings and vice versa. It's even possible to compare the same subjects in both mediums. The following points capture the general dialogue:
> - the marks used in the paintings come from drawing: Stippling, hatching, and outlining are all graphic techniques
> - the drawings appear as architectural plans of the paintings: They reveal the underlying structure of Van Gogh's vision as being highly detailed, elaborate, and constantly reinforced by the need to look and describe
> - color is so intrinsic to Van Gogh's art that it exists even when there's no pigment involved. See for yourself: These sepia drawings scream with color

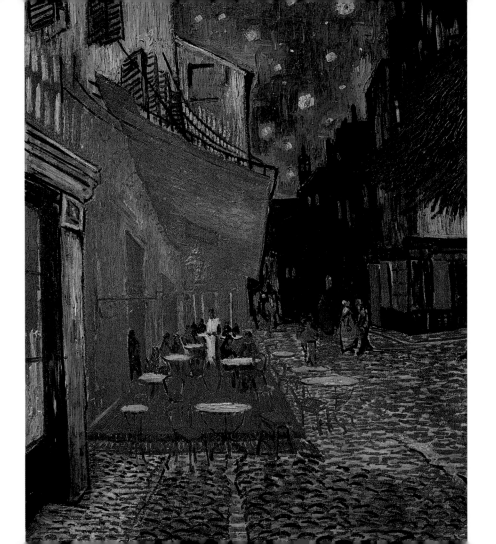

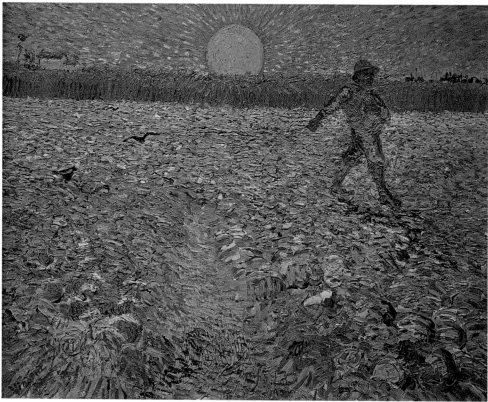

significant: It is basically a hollow stick with a sharp end, but it's also an archaic tool. For Van Gogh, its associations are twofold:

OPPOSITE
The Sower. 1888
25 ¼ x 31 ⅞"
(64 x 80.5 cm)

- exotic: It's a Japanese tool

- traditional: Rembrandt drew with a reed pen

Van Gogh used the reed pen like a brush (stroked lines) and like a pointy stylus (dots, jabs, scratches) to describe the landscape. And describe, he did: These works are characterized by thorough rendering. No detail goes unregistered. In some cases, particularly in the later Arles drawings, even the atmosphere has been accounted for—the sky is full of dots. Entire sheets of paper are covered in discursive marks. It's as if he's touching every bit of the landscape with his pen and his hand is an extension of his eye.

Surf & Turf

In June 1888, Van Gogh heads for the beach. He spends one week in the town of Les Saintes-Maries-de-la-Mer, located 30 miles south of Arles, on the Mediterranean. It's a productive trip:

- the sea and light confirm his fantasies of the South, even the Japanese ones

- he gets speedier: having gone on this holiday with the goal of making his drawing technique looser, faster, more spontaneous, and

more "Japanese" (he writes, "The Japanese draw quickly, very quickly"), Van Gogh is thrilled when he draws a boat *in an hour.*

He returns to Arles revitalized, with a new sense of color, as revealed in a painting of the seaside cottages, with pink streets and a yellow sky. This progressive streak continues with a series of paintings of the local wheatfields and with *The Sower* (1888), a related studio work (see page 60). Altogether, **this stage marks the completed transformation of his art.** Any tentative Impressionism vanishes. His own technique and vision take over, with its combination of thick, thatched, graphic impasto, and brilliant, shrill, confident colors.

From here on, Van Gogh is in full voice.

Inventing the Modern Portrait

The Seated Zouave. 1888
31 ⁷/₈ x 25 ⁵/₈"
(81 x 65 cm)

Private Collection

Van Gogh made an extraordinary series of portraits while in Arles. He wanted to modernize established tradition by creating "portraiture of the soul." Instead of showing rich burghers, kings, and dowagers wallowing in the trappings of their privileged station in life *("Hey, look at me—I'm important enough to have my portrait painted"),* he sought to paint ordinary men and women "with something of the eternal which the halo used to symbolize."

For Van Gogh, the modern portrait would not be an attribute of power and status, but a symbol of human dignity and freedom. He achieved

this goal by making portraiture a form of exchange, an act of friendship between himself and the model, and an expression of his larger sense of humanity.

The cast of portraits painted by Van Gogh in Arles is large. *Note how the backgrounds in these portraits play an important role as extensions of the subject's environment:*

- **THE ARTIST**, Eugène Boch (1855–1941), "a man who dreams great dreams," is shown surrounded by an infinite night sky. The Belgian Boch frequently visited Van Gogh at his Arles home (captured in *The Yellow House*, on page 71). Van Gogh describes this portrait as his token of deep friendship with Boch.

- **THE ZOUAVES** were an Algerian corps of the French infantry known for their distinctive uniform of baggy trousers, embroidered tops, and tasseled turbans. Van Gogh describes his Zouave as a "boy with a small face, a bull neck, and the eye of a tiger." The motif signified his relative proximity to North Africa—then known as "The Orient."

- **THE PEASANT**, Patience Escalier, appears against a fiery orange background. Vincent writes to Theo that he was first attracted to Escalier because he looked so much like their father. This is the first peasant portrait since those dirty faces of *The Potato Eaters*, but it is a major breakthrough: "What I learned in Paris is leaving me, and

I am returning to the ideas I had in the country before I knew the Impressionists." He states that he is now opposed to the Impressionists and allies himself with the great Romantic painter, **Eugène Delacroix** (1798–1863), "Because instead of trying to reproduce exactly what I have before my eyes, I use color more arbitrarily in order to express myself forcibly."

OPPOSITE
Portrait of Joseph Roulin. 1889
25 ³/₈ x 21 ³/₄"
(64.6 x 55.2 cm)

■ **THE POSTMAN,** Joseph Roulin, became Van Gogh's best friend in Arles. The various paintings and drawings that Van Gogh made of him might even be seen as a portrait of an evolving friendship. The first portrait of late July 1888 shows Roulin seated against an empty ice-blue ground. His expression is startled and wary; his arms are akimbo (i.e., hands on hips), his hands *en garde;* his beard is parted into a pair of prongs. In the last portraits of spring 1889 (as shown here), Roulin's implacable presence appears a monument of calm amidst chaos. The remarkable beard is painted with the same churning strokes that animate Van Gogh's contemporary images of the landscape. A lush green background blocks out the world like

Sound Byte:

"Roulin has a salient gravity and a tenderness for me such as an old soldier might have for a young one...[He is] such a good soul and so wise and so full of feeling and so trustful."

—VINCENT to Theo

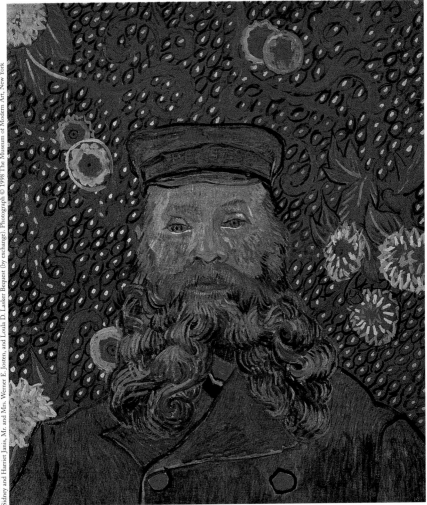

living wallpaper; flowers shoot by like fiery comets. Painted only weeks before Van Gogh leaves Arles to check himself into an asylum, this image depicts Joseph Roulin as a steadying force and a trusting friend who responds to Van Gogh's terrible physical and mental conditions with a look of calming understanding. Van Gogh admired his easy affability, his socialism, and his family life (he also painted Roulin's wife, in *La Berceuse,* and his children; see pages 84–85). The fact that he was the postman is also significant: Van Gogh lived for the mail that connected him to his brother and friends.

■ **THE ARLÉSIENNE** was a local female stereotype (a Provençal Southern Belle), famous for the classical "Greek" beauty of her aquiline and delicate features, her luxurious curly hair, her elegant black costume with its fluffy lace bodice and coquettish cap. Nary an account of Arles omits some rhapsodizing about its pretty women. By Van Gogh's account, this beauty is embodied by **Mme Marie Ginoux,** who runs the café depicted in *The Night Café* (see page 74) and of whose portrait he writes: "I have an Arlésienne at last…." But unlike a simple cliché, his image of the Arlésienne is conflicted: He shows her seated at a table with an open novel (a sign of modern life), her distracted gaze echoing the bored expression of the *Woman at a Table in the Café du Tamborin* (1887). She becomes a symbol of peasant culture caught between tradition and modern life.

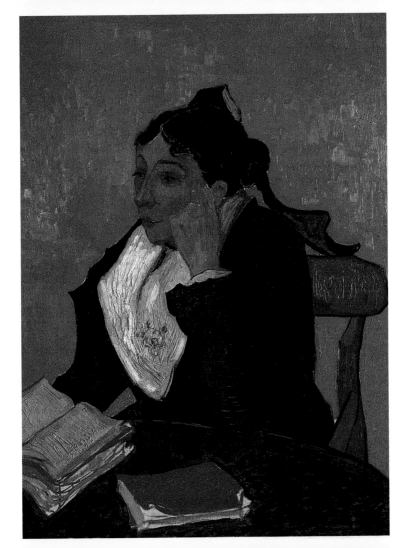

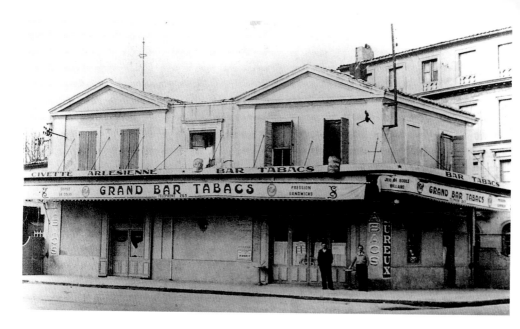

Photograph
of the
Yellow House

"THE BONZE" (i.e., Buddhist monk) is Van Gogh himself. In his self-portrait of September 1888, Van Gogh depicts himself as a bonze with a shaved head, open collar, and frail expression, worshiping the eternal Buddha. His vulnerability is accentuated by the brilliant vastness of the background, painted in solid pale malachite. In describing the portrait to his sister, he says, "I look like a Japanese."

The Painter's Yellow House

On September 18, 1888, Van Gogh moves into a yellow house on the corner of 2 place Lamartine, intending for it to be the headquarters for the artist colony he hopes to found in Arles—a place where artists will work together to create the next major style of painting after Impressionism. Unaware that he will spend less than five months here (until February 7, 1889), he furnishes it with rustic furniture, paintings, and an extra bedroom for Gauguin—decked out with pictures of sunflowers "like the boudoir of a really artistic woman." Van Gogh has been corresponding with Gauguin, whom he hopes will become the leader of his new colony of artists.

Fortunately for Vincent, his brother Theo is Gauguin's dealer; Theo arranges for the money-starved Gauguin to spend time with Vincent free of charge, in exchange for a few of Gauguin's paintings. More than

> **FYI:** The French painter **Eugène Delacroix** was hailed as the leader of the Romantic movement and celebrated as the greatest colorist in the history of French art. During the 1830s, his swashbuckling style, romantic temperament, and choices of literary and exotic themes emerged in opposition to the cool classicism of such contemporaries as **Jean-Auguste-Dominique Ingres** (1780–1867). For Van Gogh, Delacroix's art embodied an anti-Impressionist position and a bold approach to color and brushwork.

"I believe that a new school of colorists will take root in the South, as I see more and more that those in the North rely on their ability with the brush, and the so-called 'picturesque' rather than on the desire to express something by color itself."

—VAN GOGH, describing the "colorist" movement he hopes to found in the South

OPPOSITE
Vincent's House in Arles, the 'Yellow House'
1888
28 ³⁄₈ x 36"
(72 x 91.5 cm)

anything, Van Gogh feels lonely and alienated, even though coming to the South of France has given him the necessary detachment from the Impressionists and the Paris art scene that he so desperately craved. The idea of having Gauguin come stay with him fills Vincent with joy. That the act of setting up household is extremely meaningful for him is demonstrated by two key paintings that bracket his move: *The Night Café* and *Van Gogh's Bedroom* (see pages 74–75).

Not a Cozy Picture

Even though *Van Gogh's Bedroom* (also known as *The Artist's Bedroom*) was specifically intended as an antidote to the irritating interior of *The Night Café*, it's not an entirely restful image. Look closely:

- the perspective of the room tips upward to an alarming degree: all the furniture is about to slide right out of the picture and crush whomever is standing in front of it

- the bed, vastly long, is like some gaping maw

- look at all the signs of loneliness: two empty chairs, two

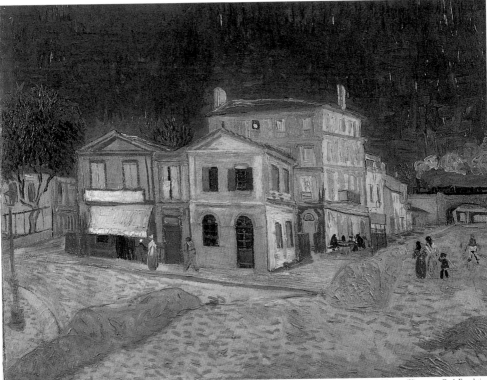

Amsterdam, Van Gogh Museum (Vincent van Gogh Foundation)

pillows, that empty bed, that empty room. The folks in *The Night Café* might appear to be alienated, but at least they are alienated together.

Paul Gauguin comes to live with Van Gogh

In early October 1888, before Gauguin arrives in Arles, he and Van Gogh exchange self-portraits. Van Gogh (the "bonze") depicts himself as a humble worshiper in the temple of art. Gauguin opts for a criminal persona, identifying himself with Jean Valjean, the rebel hero in Victor Hugo's novel *Les Misérables,* after which he titles the portrait. He paints himself as a seedy presence—dark and scowling—hunched in front of a pretty, floral background, which he designates as wallpaper in a virgin's bedroom. *Vincent is no virgin,* but when Gauguin finally shows up at The Yellow House on October 23, the invasion is no less radical than the two self-styled portraits suggest: The sinner has moved in with the saint.

OPPOSITE
The Promenade, Evening. 1889
19 ⁵/₈ x 18 ¹/₈"
(49.5 x 45.5 cm)

Gauguin had been in Brittany, where he was involved in his own painterly pursuit of the primitive, as embodied for him in western

Sound Byte:
"Instead of trying to depict exactly what is before my eyes, I am using color more arbitrarily to express myself forcefully."

—Vincent to Theo

Café vs. Bedroom:

Check out the volley of differences
between these two images.
*(Note: Van Gogh painted more
than one version of each.)*

THE NIGHT CAFÉ (1888)

(Detail)

28 ½ x 36 ¼" (72.4 x 92.1 cm)

Yale University Art Gallery, New Haven, Connecticut.
Bequest of Stephen Carlton Clark, B.A. 1903.

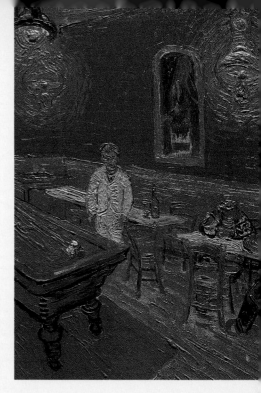

Time: Painted just before he moved into The Yellow House

Setting: Located in the all-night café below his lodgings,
where he would hang out in the evenings—a place where
drunks, prostitutes, and night prowlers could take refuge.
A homeless member of this nocturnal community, Van
Gogh identified with its marginal denizens at the same
time as he feared the connection. He described *The Night
Café* as "a place where the mind could go mad, where one
could commit a crime."

Intent: "I have tried to express the terrible passions of
humanity by means of red and green." He called the colors
a palette of nerves, and the painting one of the ugliest he
had ever done.

Light: Illuminated by sulphurous gaslight: a picture of
people keeping unnatural hours, being deprived of
sleep, zombies of modern life.

Mood: The empty foreground rushes forward to engulf
the viewer, to involve us as inhabitants of *The Night Café*.
And that ominous UFO of a shadow hovering beneath the
pool table!

Colors: The colors are specifically meant to look like those
found in cheap reproductions, like the English tabloid
prints he collected.

VAN GOGH'S BEDROOM (1888)

22 ½ x 29 ⅛" *(72 x 90 cm)*

Musée d'Orsay, Paris. Erich Lessing/Art Resource, NY

Time: Painted just after he moved in to The Yellow House: "It is going to be a contrast to…*The Night Café.*"

Setting: A study of his bedroom as he furnished and decorated it, with the portrait of Eugène Boch and other paintings in simple pine frames. This room was to be Van Gogh's haven, a nest to pamper his creativity. It was also a document of his having made his own place in the world. (He is 35 years old, after all, and the bohemian thing is beginning to wear thin.)

Intent: When he started the painting, he complained of pain and exhaustion. His eyes especially were tired. "In a word, looking at the picture ought to rest the brain, or rather, the imagination." Tragically, neither would occur.

Light: The windows are closed, shutting out the light and the world, keeping the room cool, dark, and quiet. The bed sits there, waiting to be slept in.

Mood: Van Gogh equated the broad lines of the furniture, the simple masses of unmodulated color, the lack of shadows, and the general emptiness of the room with "absolute restfulness." He likened the simplicity of the image to the Japanese prints, which he collected.

Colors: This picture was conceived as a therapy, in which "color is to do everything."

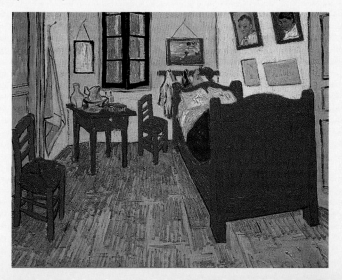

France by the Breton peasants, who were considered as ancient and mystical as the Celts. But he had run out of money, and when he shows up in Arles, he is trying to figure out how to get to his ultimate destination, Martinique—although the day Gauguin arrives in Arles, a letter from his Paris dealer, Theo van Gogh, is waiting to inform him of the sale of a painting. Nonetheless, Van Gogh is elated: For months he has urged Gauguin to come and be the leader of this community of colorists, and now Gauguin is here.

Their life together begins harmoniously: They share the same model, use the same kind of burlap canvas, and paint the same landscapes. Van Gogh shops, Gauguin cooks. To Van Gogh's relief, Gauguin brings a sense of order and responsibility to his everyday life.

INCOMPATIBILITY TEST:

Despite similarities in their approach to art, the artists achieve radically different results in their work: If a passion for color and being a colorist is Van Gogh's big thing, then Gauguin's is memory and the reliance upon it for imagining one's subjects.

Compare:

- Van Gogh's thick, lush paint; graphic brushwork; naturalistic colors pitched to high keys

- Gauguin's thin, dry surfaces; soft brushmarks; muted colors absorbed from memory

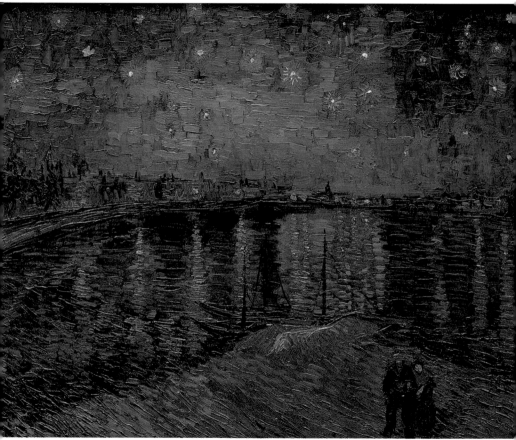

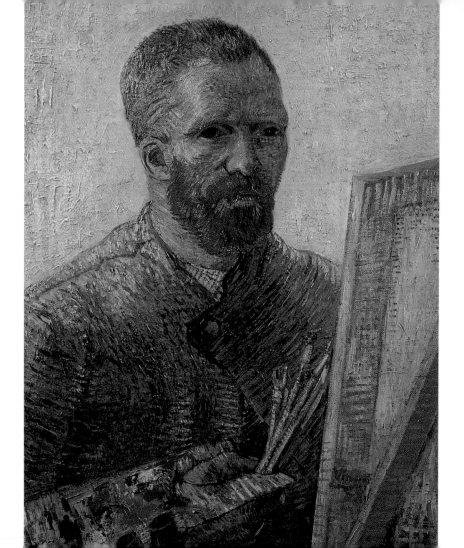

As their partnership progresses, Gauguin seems increasingly peevish toward Van Gogh. He paints his own version of *The Night Café* that stars Van Gogh's friend Mme Ginoux as a hardened prostitute and the Postman Roulin as figment of an opiated dream. Far from enjoying his new surroundings, Gauguin brutally characterizes the town of Arles as a filthy hole and has no desire to remain there, especially after learning from Theo that several of his paintings have been sold. After a few weeks, he starts teasing Van Gogh for being a slave to nature, for being so observant. He ridicules the Dutchman into painting from his imagination—from his memory—instead of from nature. Eager to please, Van Gogh conjures *Memory of the Garden at Etten,* a strange composite cobbled together from:

- memories of Holland

- mental portraits of his mother and his sister (how they look in the artist's mind)

- the invention of a fictitious "Dickensian" character in a scotch plaid shawl

Gauguin responds with the *Garden at Arles,* a picture that echoes the image of two women strolling. But he irreverently adds a caricature of his own face that moons up from a shrub at the passing ladies. From this point on and for the remaining weeks of Gauguin's visit, the two artists work distinctly separately from one another.

OPPOSITE
Self-Portrait in Front of the Easel. 1888
25 ¾ x 19 ⅞"
(65.5 x 50.5 cm)

Amsterdam, Van Gogh Museum
(Vincent van Gogh Foundation)

"Take Good Care of it"

In mid-December, Van Gogh is working on images of the Roulin family when Gauguin presents him with a portrait that shows Van Gogh in a remarkably bovine fashion, painting a still life of sunflowers. As legend has it—and this is a legendary episode in art history—Van Gogh retorts, "It is certainly I, but it's I gone mad." He throws a glass of absinthe at Gauguin, then apologizes and peace is briefly restored. But on December 23, while out strolling alone after dinner, Gauguin is accosted by a frantic Van Gogh, who is seized with momentary madness and wields a razor. Van Gogh stops short of attacking Gauguin, then runs away distraught. Alarmed, Gauguin spends the night in a hotel, and when he returns the next morning to The Yellow House, he finds a crowd of police and townsfolk huddled outside. He learns that Van Gogh had mutilated himself during the night by cutting off a piece of his right ear *(not the whole ear)*, had gone to a brothel and asked for a prostitute named Rachel, then had given her his ear, beseeching her to "keep this object carefully."

Sound Byte: 9 ½ weeks

"How long did we remain together? I couldn't say, I have entirely forgotten. In spite of the swiftness with which the catastrophe approached, in spite of the fever of work that had seized me, the time seemed to me a century."

—GAUGUIN's recollection of the time he spent with Van Gogh in Arles

PLEASE LEAVE!

Van Gogh is admitted to the Hôtel-Dieu hospital in Arles and Gauguin notifies Theo by telegram of the incident. A horrified Theo arrives for one day, then leaves for Paris with Gauguin on December 27. Van Gogh stays in hospital for two weeks, during which time Joseph Roulin visits him and sends progress reports to Theo. Van Gogh is released on January 7 and returns to The Yellow House, where

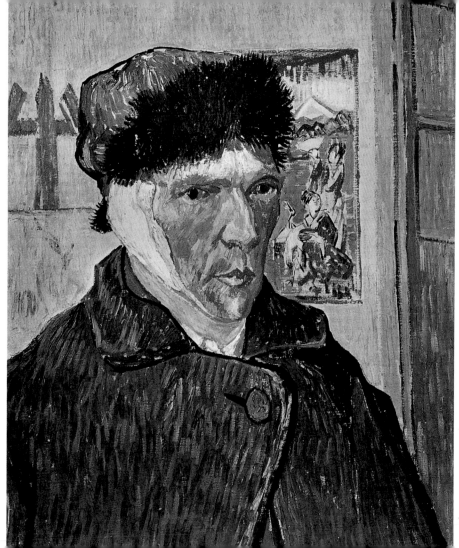

he starts painting the next day, working on self-portraits that are images of self-healing.

Observe:

- the bandaged ear: seen without pain or self-pity but with fascination

- the meditative gaze: the artist appears to be focusing his energy inward

- the composed background: balanced arrangements of color and art

FAST FORWARD: Driven by loneliness, Van Gogh paints feverishly and obsessively. In late January 1889, Joseph Roulin leaves Arles for a new post in Marseilles. A letter from Gauguin asks for the return of his fencing mask. On February 4, crisis strikes again: Paranoid that someone is trying to poison him, Van Gogh is taken back to the Arles hospital, where he hears voices and hallucinates. After 10 days he is released, to the chagrin of his neighbors, who now fear him. The people of Arles petition that he remain in confinement, or better yet, *please leave town.* The police bar him from The Yellow House. On February 25, he is readmitted to hospital, "shut up in a cell all the livelong day" without paints, books, or pipe. His health improves and in late March he is visited by the Pointillist painter, **Paul Signac** (1863–1935). Together they go to The Yellow House, where Signac breaks in and they find Van Gogh's art intact. On March 30, Van Gogh celebrates his 36th birthday in a relatively good frame of mind. He is painting again, out in the orchards. On April 17, Theo gets married in Holland.

OPPOSITE
Self-Portrait with Bandaged Ear. 1889
23 ⁵/₈ x 19 ¼"
(60 x 49 cm)

Double-Entendre: Lullaby Lady

LA BERCEUSE (1889)
36 ½ x 28 ¹¹/₁₆" (92.7 x 72.8 cm)

What: In French, a *berceuse* is a woman who rocks a cradle. It is also the word for lullaby. In her portrait by Van Gogh (of which there are five versions), Madame Augustine Roulin (wife of the postman) is intended to represent "la berceuse" in both senses of the word.

How: Note that she is holding a rope. This would have been attached to a cradle, but by leaving the baby offstage, Van Gogh has left the connection open to bigger ties.

The Big Picture: In writing about this painting, Van Gogh refers to a favorite novel by Pierre Loti entitled *Pêcheur d'Islande* (1886). This tale of Breton fishing life inspired Van Gogh to see the cradle rope in the woman's hands as a symbolic rescue line to men whose lives were at risk on the seas. Van Gogh envisioned this portrait as the center of a triptych, flanked on either side by a painting of sunflowers in a vase. The triptych, he suggests, would be erected on board a fishing boat, where it would comfort the sailors with an image of their maternal home, of the land (represented by the sunflowers), and of its people. By offering this symbolic connection, Van Gogh intends the painting as a therapeutic image for anyone whose life is adrift. He compared his aims to what he found in the music of Richard Wagner (1813–1883) and Hector Berlioz (1803–1869) to create with *La Berceuse* "a consoling art for broken hearts."

An intimate detail: The "wallpaper" Van Gogh invented for Mme Roulin is the same as the background in the contemporary portrait of her husband (see page 64). Incidentally, at the time Van Gogh was working on these portraits, Joseph Roulin was transferred from Arles to Marseilles and was temporarily separated from his wife and children. Could the common background Van Gogh created in their portraits also have been his way of keeping the family together during this period?

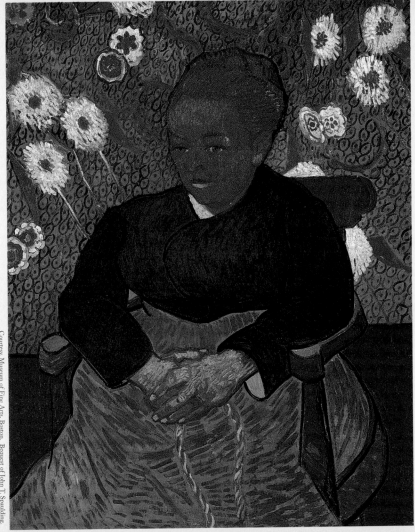

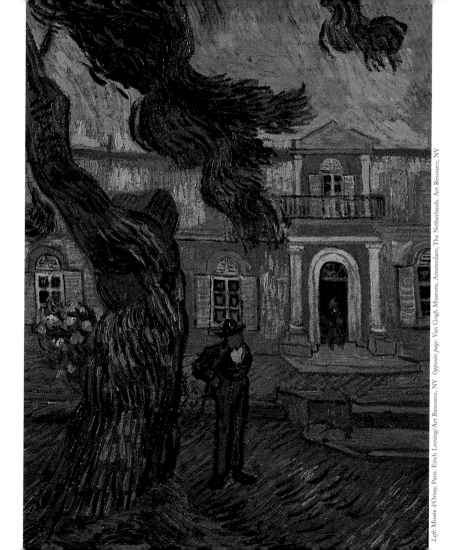

A few days later, suffering yet again—and now unable to live alone anymore—Van Gogh agrees with a local preacher's suggestion that he enter an asylum in nearby Saint-Rémy-de-Provence. His final images of Arles include views of the hospital dormitory and garden.

ABOVE
Vase with Irises
1890
36 ¼ x 29 ⅛"
(92 x 73.5 cm)

OPPOSITE
St. Paul's Hospital at Saint-Rémy
1889
23 x 17 ¾"
(58 x 45 cm)

From Sunflowers to Irises: Saint-Rémy

Saint-Rémy-de-Provence, located about 50 miles north of Arles, is a beautiful town of gorgeous gardens, flowers, and magnificent old trees. It is surrounded by elegant, barren mountains, the colors of which establish a new palette for Van Gogh: from the sun-baked Arles, to cooler blues, grayish greens, and violet; from sunflowers to irises.

Roman ruins lie outside the town; inside, an asylum. Van Gogh arrives by train at the asylum of Saint-Paul-de-Mausole on Wednesday, May 8, 1889 and will remain here for one year. Within the first week, he has painted *Irises* (see page 89), an image that stands alone in Van Gogh's paintings of flowers for its intoxicating beauty: The composition is tight, claustrophobic, entirely filled with richly colored flowers, leaves,

FYI: In the ten years Van Gogh was active as an artist, he produced about 1,000 drawings, watercolors, and sketches, and 1,250 paintings. If he worked a five-day week (which he didn't), that would be almost one image a day, every single day.

87

and dirt. Upon seeing this packed picture exhibited at the Salon des Indépendants in Paris, the critic Félix Fénéon commented: "The irises violently slash their petals to pieces upon swordlike leaves."

The Multimillion Dollar Painting: *Irises* (1889)

OPPOSITE
Irises. 1889
28 x 36 ⅝"
(71 x 93 cm)

Irises is a study from life of a corner of the asylum garden—the only place Van Gogh was allowed to work when he first arrived at Saint-Rémy. The lack of open space within the frame might suggest Van Gogh's own restricted freedom. However, the artist only discussed the painting in terms of its *close proximity to nature:* He called it a "study" to distinguish *Irises* from his other "pictures" of flowers. This distinction underscores the Northern imperative of Van Gogh's art in general—the need to directly observe and describe reality in detail. As in his paintings of sunflowers, he's searching for individuality: *Amidst all the purple blooms, one white iris stands alone, a symbol of the lone painter.*

Sound Byte:
"In the popular view, Van Gogh has become the prototype of the misunderstood, tormented artist who sold only one work in his lifetime, but whose Irises *(sold at Sotheby's in New York on November 11, 1987) achieved a record auction sale price of £49 million."*

—EVERT VAN UITERT, art historian

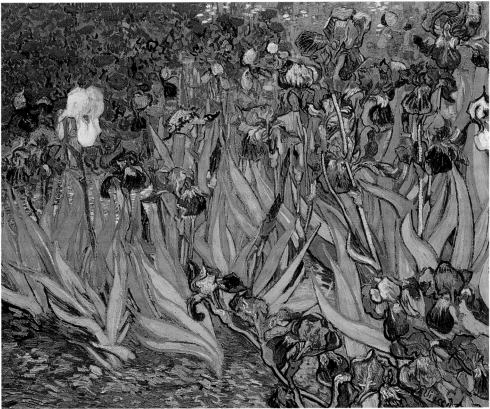

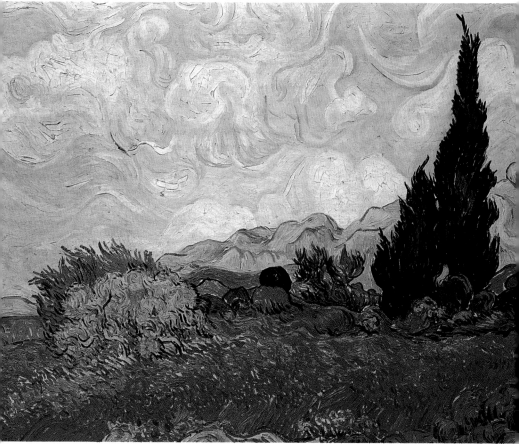

Essential Characteristics of the Saint-Rémy Paintings

As Van Gogh settles into work at the asylum, his painting develops some distinct characteristics:

- a sense of anxiety about unstructured and empty spaces

- brushstrokes that whorl and churn, slabs of paint slapped down like bricks, every nook and cranny of the surface *built* to describe: air, rocks, flowers, trees, and stars

- paint becomes a vital and reassuring substance with which *to fill the void of Van Gogh's canvas*

The Big Motifs at Saint-Rémy

Despite constant attacks of delirium, Van Gogh is extremely productive in the asylum and **explores a huge range of motifs.** Not only does he work from nature, but he returns to old sketchbooks or works directly from memory. Painting from inside the asylum, his main themes include:

OPPOSITE
Wheatfield with Cypress Trees
1889
28 ¾ x 36 ¼"
(72.5 x 91.5 cm)

- **WALLS, WINDOWS, CORRIDORS**—conflicted signs of security and confinement

- **THE GARDEN**—a source of still-life subjects

- **SELF-PORTRAITS**—painted in his studio, overlooking the garden, against empty grounds, *with everything swirling with paint*

- **THE FIELDS AND MOUNTAINS**—as seen from inside the walls of the asylum

He also ventures outside the asylum, where he paints:

- **OLIVE TREES,** gnarled and tortured by the ferocious winds of the mistral, which, incidentally, is also doing a number on Van Gogh, who complains that these incessant winds are leading to his disenchantment with Provence

- **CYPRESSES,** a classical symbol of strength and endurance. Van Gogh turns them into microcosms of turbulence and self-torment

- **THE LOCAL QUARRY,** a Cézanne-*esque* theme of the earth painfully ripped open

Perhaps in an effort to find security and peace of mind, he also returns to his own archive of images: *Old Man in Sorrow* (old man with his head in his hands, waiting for death; see page 27), *Van Gogh's Bedroom,* and *L'Arlésienne* reappear as new paintings. He also copies works by other artists, whom he

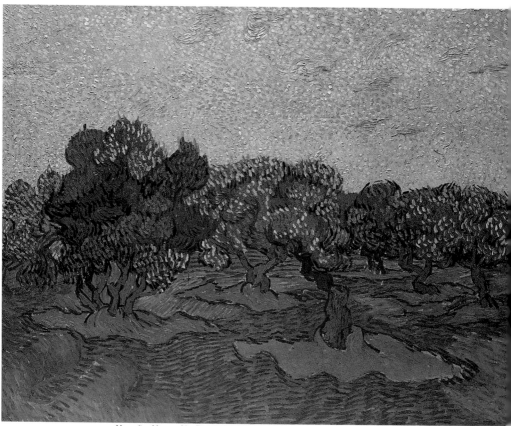

appears to select as reinforcements of his own identity as an artist—in particular, Daumier, Delacroix, Doré, Millet, and Rembrandt. It's as if Van Gogh is creating a personal pantheon for himself to enter. But the moment arrives when he is ready to create one of the most extraordinary masterpices in all of European art: *The Starry Night* (see page 96).

OPPOSITE
Olive Orchard
1889
28 ⁵/₈ x 36 ¹/₄"
(72.7 x 92.1 cm)

His Big Work: *The Starry Night*

Here it is. But before going into it, pause for a quick reality check:

- Van Gogh is 36 years old

- it's June and he's been living in the enclosed world of an asylum for a month, suffering intermittent mental breakdowns

- thirteen months from now, he will be dead

- he has received no significant attention as an artist, save his brother's steadfast support

- his big dream of founding a community of artists in the South of France was a *horrific failure*

Seeds of Recognition

At Saint-Rémy, Van Gogh experiences long periods of clarity, ruptured by violent attacks—one of which lasts from July to mid-August, dur-

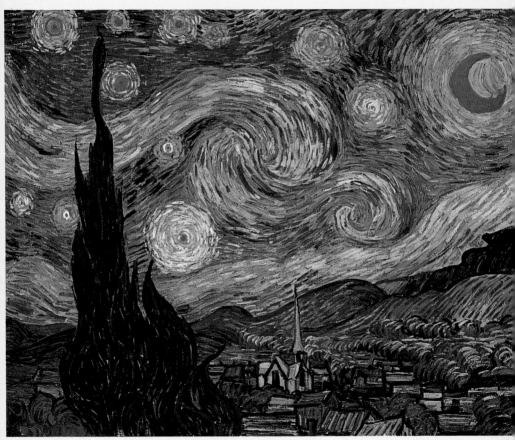

THE STARRY NIGHT (1889)

29 x 36 ¼" (73.7 x 92.1 cm)

What: A nocturne (i.e., night picture) of the Provençal landscape with cypress trees, village, and mountains beneath a crescent moon within a star-studded and cataclysmic universe.

Why: (This is complicated, but fascinating.) Given how much he tended to verbalize about his art (his letters brim with news about his progress, his intent, etc.), Van Gogh was unusually quiet on the subject of this picture. He merely tells Theo that he is painting a new starry night, thus referring to the "other" *Starry Night Over the Rhône* (see page 77), which had painted the previous year in Arles. The Arles painting was a manifesto of Van Gogh's adamant belief that nocturnes should be painted at night—when all of the colors of darkness were apparent—and not by daylight in the studio the following morning. *(In other words, he was asserting his naturalistic approach against Gauguin's encouragement to paint from memory.)* But the "new" *Starry Night* couldn't have been painted from nature, since that view doesn't exist: Van Gogh couldn't see the mountains from his studio window at the asylum, so he must have painted them at night from other images and pure recollection. Even more fascinating is the church steeple: *They don't have steeples like*

that in Provence. But such pointy spires are absolutely typical of churches in Dutch villages. Thus, *The Starry Night* is a powerful act of invention, deliberately constructed as an abstraction based on memory, reality, and imagination. For Van Gogh, it is a willful act of freedom—spiritual, personal, symbolic, abstract, and interpretive liberation—achieved through art.

The Point: This is a picture of cosmic convulsion: chaos is represented as part of universal order. The night sky roils over the earth; the church makes a small stab at connecting with the stars, but it's the cypress tree in the foreground (nature) that achieves a reach heavenward. Some critics venture that Van Gogh sees himself as the bright new star, in a kind of premonition of his death and ascension into the heavens. (There was a contemporary belief that souls go straight to a star.)

The Paint: The surface of this painting is *pulsing*: short brushstrokes (evolved from Pointillism), stippled and swabbed, set a staccato rhythm; black lines (holdovers from Cloisonnism) sinuate the surface; the drawing makes everything attenuated and bizarrely elegant; the colors are snatched directly from daylight and are electrified.

ing which time he develops a fear of going outdoors. In September, the eleven paintings (including *Irises*) that Theo had submitted to the Salon des Indépendents garner some critical attention. In October, he receives a copy of a publication in which the Dutch critic, J. J. Isaäcson, mentions the painter enthusiastically. Van Gogh modestly chides Isaäcson's words of praise as "highly exaggerated."

Christmas, never a good time for Van Gogh, brings on another attack that lasts until New Years Day. In early January, delusional again, he attempts to eat his paints. (Theo advises him to concentrate on drawing, not painting, for the time being.) In Brussels, his art is included in the 7th annual exhibition organized by the Belgian Post-Impressionist group, Les XX (i.e., Les Vingt, *The Twenty*), which opens on January 18, 1890. Van Gogh does not attend the exhibition but travels the short distance to Arles to visit Mme Ginoux, the *Arlésienne*, who is ailing from nervous complaints not unlike his own. In late January, he receives reviews of the Belgian show and a copy of an essay devoted to his work by the critic Albert Aurier in the periodical *Mercure de France*. **Aurier hails Van Gogh for showing contemporary artists a way out of Impressionism.** Himself a Symbolist poet, Aurier is also perhaps the first to launch the lunacy angle, writing that Van Gogh is "a fanatic, an enemy of bourgeois sobrieties and petty details…a brain in eruption, irresistibly pouring its lava into all the ravines of art, a terrible and maddened genius."

More good news: Gauguin writes to ask Van Gogh if he would like to consider setting up household together in Belgium with another artist, Meyer de Haan. Happy for the invitation from his favorite nemesis, Van Gogh nonetheless decides he's better off alone in Saint-Rémy. Theo and Johanna's son is born on January 31; they name him Vincent Willem van Gogh, after the painter.

In February, Van Gogh suffers further attacks. Even the momentous event of his **first sale**—in March the painting *Red Vineyard* sells in Brussels for 400 francs—is clouded by a long period of illness.

As his depression recedes, Van Gogh begins to express a desire to leave his adopted home of Arles and head north, toward his native Holland. On May 16, he leaves Saint-Rémy and goes to Paris, where he spends three days with Theo and his family. Johanna's touching account of the visit begins with a recollection of her husband's anxiety at its prospect: *What state would Vincent be in?*

To everyone's relief, Vincent arrives from the asylum robust, smiling, and suntanned. He beams at the baby and basks in the abundant display of his own art, which crams Theo's apartment to the point that pictures are piling up under the beds. Soon, however, the noise and bustle of Paris grow overwhelming and Van Gogh decides to move to nearby Auvers-sur-Oise.

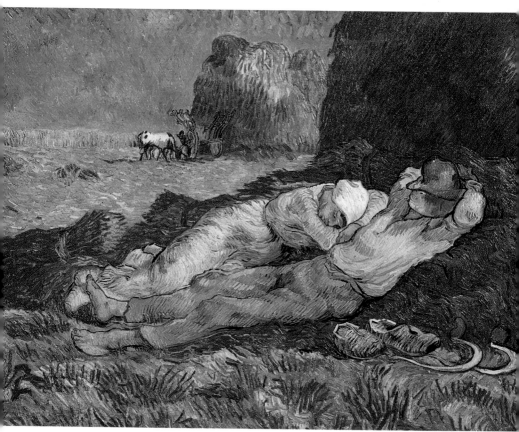

Ending His Life in Auvers-sur-Oise

Auvers lies on the River Oise, 20 miles northwest of Paris—a distance that proves attractively short for artists, who have habitually settled in this cultured and quaint little town. The Barbizon School painter Charles-François Daubigny had lived there until his death in 1878 and Cézanne had worked there intermittently during the early 1880s.

When Van Gogh arrives in Auvers on May 20, he is met (through previous arrangement with Theo) by **Dr. Paul-Ferdinand Gachet,** a friend and patron of artists, including Cézanne, Pissarro, Monet, and Renoir. Gachet is an artist himself—he sketches Van Gogh on his death bed—and, like the Postman Roulin, is a socialist. The doctor, whose house is filled with art and antiques, immediately strikes Van Gogh as an eccentric, more nervous even than himself. Following these impressions, however, Gachet becomes Van Gogh's friend and companion. He reveres Van Gogh's talent and sees to his well-being throughout the next three months. Van Gogh spends his remaining days visiting with Gachet, writing letters, and painting. Having taken lodgings in the attic of a local inn, Van Gogh is persistently troubled by the question of what to do with his paintings, which the dealer Tanguy is storing for him in Paris.

Many people cared for the artist during his times of illness and Van Gogh pays tribute to them in a series of portraits. Dr. Gachet is one of them (see page 105). The portrait of Dr. Gachet is perhaps *the ultimate*

OPPOSITE
La Méridienne (The Siesta), after Millet
1889–90
28 ³/₄ x 35 ⁷/₈"
(73 x 91 cm)

modern portrait, as Van Gogh intended it: We feel we know and like this humane man whose expression of weary melancholy suggests that he is burdened by the suffering he has seen. The good doctor wears a kind of personal uniform, consisting of the same hat and trench coat worn on even the hottest days. He practices homeopathic medicine: The foxglove flowers on the table are the source of digitalis, a natural heart medicine for treating nervousness.

In Auvers, Van Gogh also paints the village church (see page 105), a deliberate echo of the church in *Peasant Cemetery,* painted nine years earlier in Nuenen (see page 33) and views of the pretty town, its gardens, and nearby vineyards. Collectively they form a concentrated body of work, but in terms of the overall structure of Van Gogh's art, these pictures appear to be falling apart from within:

- the compositions are less centralized

- the brushwork tends to be finicky

- the drawing can be brittle

In June, Theo and family pay Vincent a visit in Auvers. The pleasantness of that afternoon does not carry over to Vincent's next trip to Paris in July. Despite the company of friends, such as Toulouse-Lautrec (who makes undertaker jokes), this visit is marred by Vincent's mounting distress over the storage of his art, which he considers inadequate.

Back in Auvers, tension and anxiety continue to grow, and on July 27, Van Gogh carries his easel out to a field, props it against a haystack, and shoots himself in the chest. He manages to drag himself back to the inn, where he is found by Dr. Gachet, who summons Theo from Paris with a note, "With the greatest regret, I must bring you bad tidings...." When Theo arrives, he finds Vincent to be in better shape than expected (subsequent evidence suggests that the wound was not, in fact, fatal, but that Van Gogh died of infection from the unremoved bullet). As Vincent's condition rapidly worsens, Theo remains by his brother's side and hears his last words.

Vincent van Gogh dies on July 29. The funeral, held the next day, is attended by artist-friends from Paris, including Emile Bernard. Van Gogh's coffin, laid out in the parlor of the inn, is surrounded by his final paintings, by masses of yellow flowers (sunflowers and dahlias), and by his painting equipment (easel, brushes, paints, and stool). His body is buried in a small cemetery in Auvers.

Distraught over his loss, Theo writes to their mother, "Vincent said, 'I would like to go like this' and half an hour later he had his wish. Life was such a burden to him; but now, as often happens, everybody is full of praise for his talents.... Oh, Mother! He was so my own, own brother." Vincent's death devastates Theo, whose frail health collapses and who dies six months later on January 25, 1891. He is buried next to his brother in Auvers.

Closing shots: What's to know about Van Gogh?

- he was a Pre-Expressionist artist of the Post-Impressionist period

- he felt what it was to be modern—artistically, socially, and intellectually

- he cut off only *a piece* of his ear

OPPOSITE

LEFT
The Church at Auvers–sur–Oise
1890
37 x 29 ³/₈"
(94 x 74.5 cm)

RIGHT
Portrait of Dr. Paul Gachet
1890
26 ³/₄" x 22 ¹/₂"
(68 x 57 cm)

- the meaning and content of his paintings are *absolutely* calculated down to the last cool drop of lilac paint

- he created an imagery that changed the way people see the world

The Pre-Expressionist painter

Van Gogh is considered the official forerunner of **Expressionism,** one of the most important currents in 20th-century art. Indeed, his letters to Theo read as primers in how-to-think-like-an-Expressionist. Expressionism ended a tradition in Western Europe that had begun in the Renaissance—namely, that art was supposed to objectively reflect and adhere to nature. In Expressionism, however, art reflects interior conditions and the artist's subjective vision by way of artistic exploitation: Line, color, spatial compositions, distortion, and exaggeration are all manipulated for their expressive potential and power to visually express highly individual, unique emotions. The mission of Expressionism was the palpable need to communicate

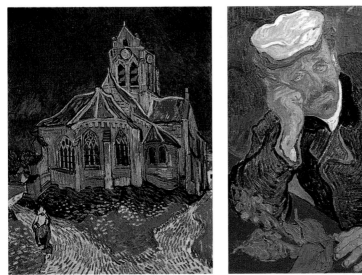

abstract feelings in a concrete fashion. Even the Impressionists, who called themselves "Painters of Modern Life," were still basically trying to represent the world—a moment, a ballerina, a haystack, an urban scene—exactly as they saw it. As a Post-Impressionist, Van Gogh advanced the notion of pictorial reality (or art) as something separate from nature. Through his work, art was seen as an expression of intellect, emotion, mystery, and imagination.

What makes Van Gogh's Post-Impressionist art particularly significant for Expressionism is that he, more than his peers, exaggerated nature

to specifically express his feelings about the human condition. The reason that Van Gogh is considered a forerunner—and not a bona fide Expressionist—is that his work evolved in terms of Impressionism: It never fully breaks from nature, or from the observation of nature, into the realm of pure abstraction. Expressionism *per se* comes in 1911 when German critics coined the term to describe the work of the Fauves, the early Cubists, and other artists adamantly opposed to Impressionism. Expressionism is a recurrent aspect of modern art, manifested throughout the 20th century:

- from Fauvism (Henri Matisse, 1869–1954) to Futurism (Umberto Boccioni, 1882–1916)

- from German Expressionism (Ernst Ludwig Kirchner, 1880–1938) to Abstract Expressionism (Jackson Pollock, 1912–1956)

- and, in a class of his own, the Norwegian Symbolist, Edvard Munch (1863–1944), whose painting *The Scream* (1893) embodies all Expressionist angst to follow

The art of Vincent van Gogh anticipates and informs all of the above.

The Five Big Conflicts in Van Gogh's Art

You really begin to *get* Van Gogh when you see the major conflicts that provoked and inspired him:

1. painting the material world—**vs.**—giving symbolic form to intangible perceptions, thoughts, and feelings

2. yearning for a simple life, close to the earth, peasants, and nature—**vs.**—a desire to create contemporary art, to establish a community of colorists, and to participate in sophisticated urban culture

3. religious conviction, a desire to alleviate spiritual suffering—**vs.**—a social conscience, a desire to educate and reform

4. desire for community, family, and a sense of permanence—**vs.**—need for solitude and isolation, a constant search for fulfillment, a sense of his own marginal life and of the alienating intensity of his personality

5. the strength of his Northern heritage, from painters Pieter Breughel (c. 1525–1569), Albrecht Dürer (1471–1528), and Rembrandt (1606–1669), and from a tradition of art that seeks to describe the *particular* in extreme detail—**vs.**—the vitality of the French avant-garde, with new systems of representation based on ideas, not on observation

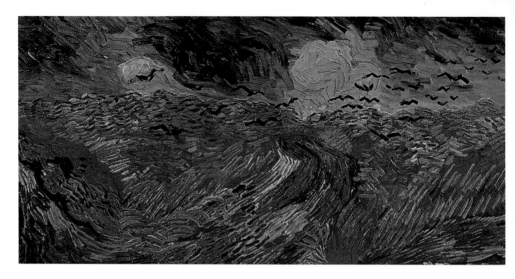

Which came Last?

For years, art historians have debated the question: Which painting was Van Gogh's last? The **sensational** (hence favorite) candidate was always *Wheatfield with Crows,* an image heaving with anguish, painted in a hail of brushstrokes, associated iconographically with Judgment Day: The road punched into the wheatfield just *ends.* But for an image of closure, with a sense of resolve and conflict, the **sophisticated** choice was *Daubigny's Garden,* an homage to Daubigny, one of the artists whose work first attracted Van Gogh. The enclosed garden was, for Van Gogh, an image of unnatural confinement. In his last letter, he wrote of this picture, "It is one of my most purposeful canvases."

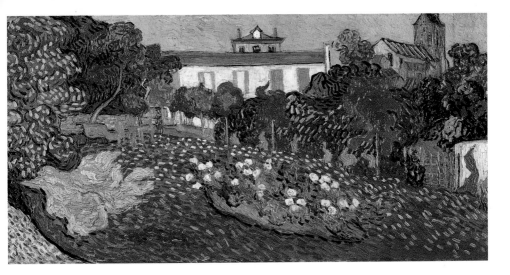

In 1994, to the astonishment of the entire art world, when Russia revealed its holdings of paintings taken from collections in Germany during World War II, a very persuasive candidate for the last painting came to light: *The White House at Night* (see next page).

Daubigny's Garden. 1890
21 x 40 ¾"
(53.2 x 103.5 cm)
Hiroshima Museum of Art

Here's why people line up to see Van Gogh

As Theo ruefully observed of the hard-won praise and recognition for his brother's genius, Vincent van Gogh *mania* was ignited almost instantly upon the artist's death. Unable to organize a tribute himself, it was Theo's widow Johanna who put together the first major survey of Van Gogh's work in 1892 in Amsterdam.

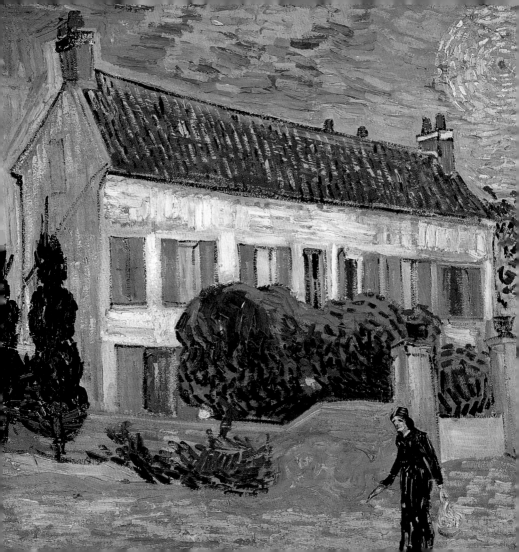

THE WHITE HOUSE AT NIGHT (1890)

23 ¹/₄ x 28 ¹/₂" (59 x 72.5 cm)

Courtesy The State Hermitage Museum St. Petersburg

What: Like *The Starry Night*, this too is a nocturne—the suburban version. It shows a modern, pretty villa, typical for the charming town of Auvers, bathed and glowing in celestial light. Three women are out walking; the night is still. Nature, represented by landscaped trees and garden shrubbery, is tamed and artificial.

Where: Auvers has the charms of rural landscape and Van Gogh hopes it will be a haven of calm and comfort. (Plus the local doctor loves artists, like Cézanne, who, during his 1872–74 stay in Auvers, made paintings of the doctor's house.)

Why: Van Gogh spends his first months in Auvers getting to know his new town. He loves its beauty and hatches a plan to paint a series of anecdotal pictures to capture its charms. He starts with the thatched cottages on its outskirts, then moves into town, where he paints particular houses, deliberately avoiding those that Cézanne had already painted.

A House, not a home: From his early depictions of his parents' house, *The Parsonage at Nuenen* (where he felt like an invasive mutt), to *The Yellow House* at Arles (where he hoped to reside with a family of artists), the "house" is rarely a home in Van Gogh's art. Despite its stark serenity, this painting is full of puzzling notes. For one, it's terribly bright for a nocturne. The point of illumination, that haloed star, looks plucked right out of the sky of *The Starry Night*. Then there's the three women out walking. In terms of Van Gogh's art, people are meant to be at home in their beds, sleeping at night, not out and about. Drifting about in the unnatural light, the women might even be seen as wandering spirits. They certainly seem like specters of imagination. Finally, there's the house itself, set back into the picture plane as if withdrawing from approach. Altogether, these notes add up to a nuanced painting, constructed from memory and artifice, projection and observation.

When: In a letter to Theo on 17 June 1890, Van Gogh mentions that he's making a study of "a white house among trees, with a night sky and an orange light in the window and dark greenery and a note of somber pink." Given the changes in the final version—the pink is gone and the trees are pruned down—Van Gogh obviously continued to develop this image. And though it may or may not be his last painting, it is the latest painting by Van Gogh to come to light in recent scholarship.

He came to art through a passionate desire to "make a difference" in the world. Working in Belgium and Holland, Van Gogh expressed his humanitarian and moral impulses by creating dark, representational paintings that depicted peasants and laborers. But illustrating other people's suffering did not allow Van Gogh to express his own highly complex feelings and involvement with life. That prompted him to leave for Paris and to grapple with the most sophisticated art of his day—Impressionism. But in two short years, Van Gogh had blasted through that, too. He assimilated the main precepts of the movement (brushwork, color, and composition were all potentially artificial constructions to be used with specific intent) and rejected others (in particular, that the aim of art was to reproduce almost scientifically the visual effects of color, light, and movement).

Now that he had the know-how, he needed content—for which he looked inward. Paris was too urban and full of distractions, so he headed south to Provence, where he evolved his unique vision of the world through the use of intense color, aggressive brushwork, and bold, thick application of paint. His paintings express this vision through a dynamic tension between internal and external frames of reference: All are rigorously put at the service of expressing the artist's keen visual and emotional intelligence and experience with the conditions and conflicts of modern life. That's what makes Van Gogh irresistible and timeless.

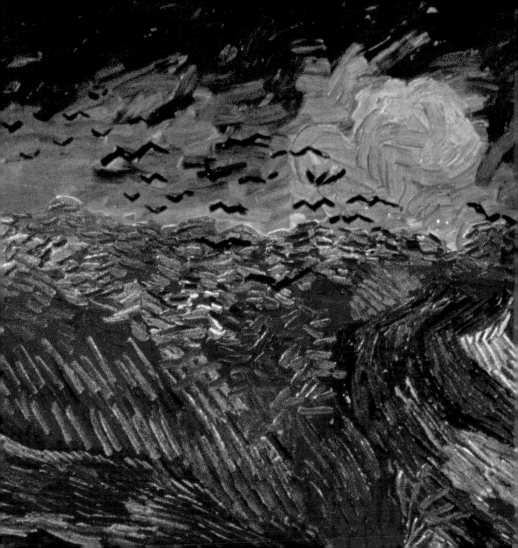